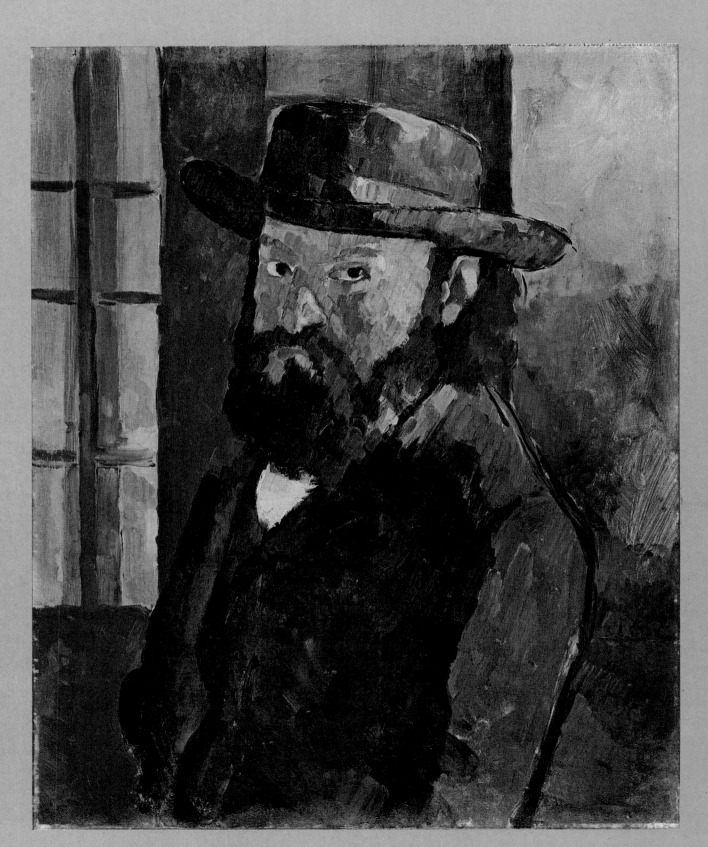

Self-Portrait with a Hat, 1879-1882.
Canvas, 25⅝ × 20 in.
Bern, Kunstmuseum.

Paul
Cézanne

Marcel Brion of the Académie Française

Exeter Books

NEW YORK

Cézanne

by Henry Moore

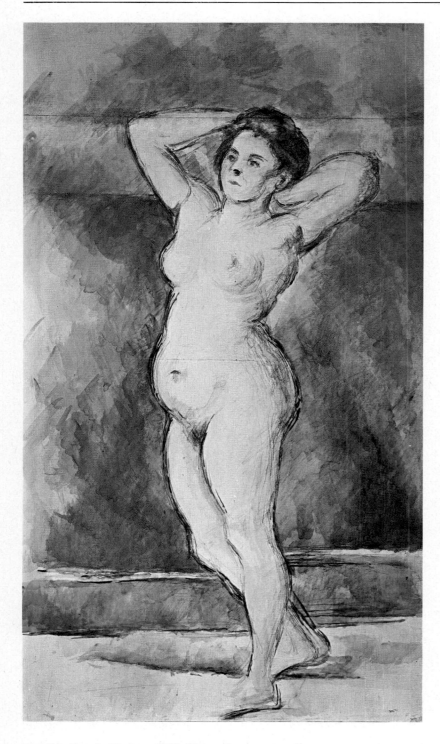

Standing Female Nude, c. 1895. Watercolor over pencil sketch, (on two pieces of paper pasted together), 35 × 20⁷/₈ in.
Paris, Musée du Louvre.

In my first year at College, I thought I would like to see some original Cézannes, and so I asked if I could go to Paris for a week. My Professor said, "Yes, and I will give you some introductions," and he did give me one to Maillol, in fact, which I was too shy to use. I got the door and I thought, "Well, he is working, and he won't want to be bothered," and so I turned away.

But I did go to see the Pellerin Collection, and what had a tremendous impact on me was the big Cézanne, the triangular bathing composition with the nudes in perspective, lying on the ground as if they had been sliced out of mountain rock. For me this was like seeing Chartres Cathedral.

In this kind of composition I think that Cézanne was trying to compete with all the things he admired. He was trying to do all he knew in it. In some of his things he was trying to learn, trying to find out, and to reduce his problems to a single one. But in this, he is competing with everything in picture-making that he knew about.

I do not like absolute perfection. I believe one should make a struggle towards something one cannot do rather than do the thing that comes easily.

Perhaps another reason why I fell for this picture is that the type of woman he portrays is the same kind as I like.

Each of the figures I could turn into a piece of sculpture, very simply.

Not young girls, but that wide, broad, mature woman, matronly. What a strength... almost like the back of a gorilla, that kind of flatness. But it has also this, this romantic idea of women. In fact, that is the thing about Cézanne: he was ready to pit himself against all that he admired, against the old masters. He was not satisfied with Impressionism. He said: "I want to make Impressionism an art of the museum," which it is not—which means that when he went to the museums and saw Rubens and El Greco, Tintoretto, he knew there was something missing, something not wide enough—broad enough—deep enough—in Impressionism. That is, his life was one monumental struggle and aim to extend himself and painting and art generally.

Life and works

A heroic life

Men Playing Bowls, 1872–1875.
Canvas, $6^3/4 \times 9$ in. U.S.A., Private collection.

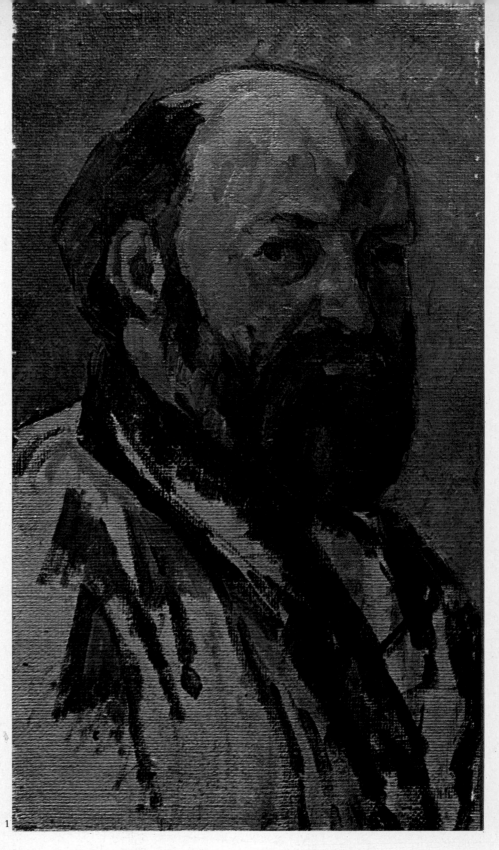

Cézanne's was a dedicated and a *heroic* life, in the strongest sense of the term; a life governed by a single passion, a single idea, in which social and even family concerns occupied the smallest possible place. The path of his life is recorded in his works, for those works were its sole purpose. If ever a man lived only in order to paint, that man was Paul Cézanne. Other painters too, of course, have sacrificed everything to their art: Gauguin and Van Gogh come at once to mind. To their contemporaries in the late nineteenth century, they were misfits, and the exclusive devotion of Gauguin and Van Gogh to their art meant that they were dogged all their life by poverty, incomprehension, doubt, and even despair. For Cézanne, however, this exclusive vocation was the source of what might be called a supreme blessing.

True, he experienced all the torments of doubt and misgivings, and while there may be a streak of romanticism in his youthful remark "the sky of my future is absolutely black," he had his periods of discouragement and dejection. Sustained, however, by a secret conviction of his genius and that strange mixture of immoderate pride and humility which marked his character, he never suffered from that slackening of the creative impetus which appears at intervals in other painters. When he likened himself to an almond tree which regularly yields its fruit in due season, he recognized the organic, biological principle of inner growth which, for him, made the act of painting the vital act par excellence. His grief, when he came to die, lay in leaving unfinished pictures behind him. The superhuman aims he fixed for his art presupposed an impossibly long life. From the moment he "entered into painting" as one "enters into religion," he never swerved from the vow implied in that commitment: to enlist in the service of painting all his energies, all his dreams, all his powers of invention and achievement.

As a rule, an artist's self-portraits are our best introduction to him as a man; for Rembrandt, Van Gogh, Courbet, Titian, and many others, they have much to tell us about the artist's thoughts and passions and inner life. Cézanne is an exception; his self-portraits tell no secrets. His face is a closed door, which neither our curiosity nor our sympathy can force open. It is as if he were wearing a mask. So true is this that one is quite ready to credit the tradition, still current in Aix-en-Provence, which has it that Cézanne rigged out the models for his *Card Players* in carnival masks. Despite the systematic secrecy he observed, and also respected in his sitters, never trying to catch those tell-tale

expressions which every face betrays, there is much to be learned about his personality from a character study of his self-portraits. The aloofness which he so carefully maintains, keeping the spectator at arm's length, hints at the underlying oddities of a man who kept repeating that he would not let anyone "get their hooks" into him. This colloquial expression demonstrates the fierce independence and self-reliance that drove him on, the stern resistance he offered to any interference in his private affairs, the dread he had of any outside influence, whether technical or aesthetic, that might tarnish the purity of his art. He was regarded by his contemporaries as a misanthrope because he shrank

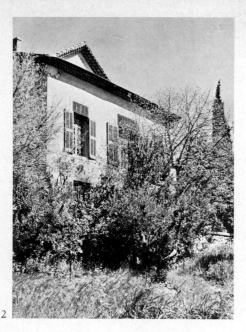

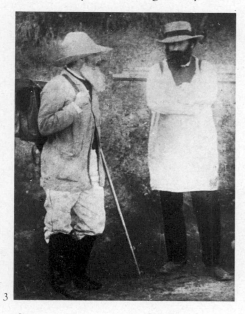

1 Self-Portrait, c. 1880-1881. Canvas, 10 × 5³/4 in. Paris, Musée du Louvre, Jeu de Paume. (Photo AGRACI)

2 Cézanne's house and studio in Aix-en-Provence, photograph. (Photo Sauvageot-Viollet)

3 Camille Pissarro (left) and Paul Cézanne (right), photograph. (Photo Roger-Viollet)

4 Cézanne painting at Aix-en-Provence, photo taken by Maurice Denis and Émile Bernard in January 1904. Paris, Sirot Collection.

5 Interior of Cézanne's studio in Aix-en-Provence, photograph.

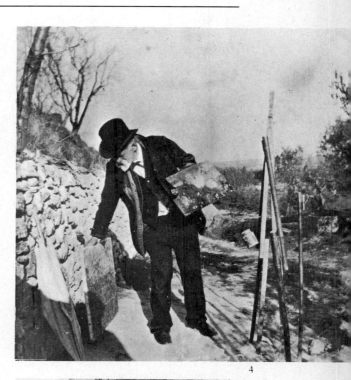

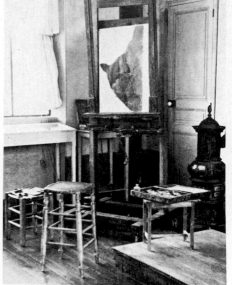

from physical contact with others. Though capable of genuine friendship, he would allow no one, not even his closest friends, to touch his shoulder or take his arm—symptoms which today may be of considerable interest to psychiatrists, but which in Cézanne's time simply led people to write him off as unsociable. Yet he responded to a frank show of sympathy and a sincere note of admiration, especially when, in his maturity and old age, they came from younger men of generous enthusiasms like Léo Larguier and Joachim Gasquet, two poets who made no secret of their cult for the "Master of Aix" at a time when the local populace was more inclined to laugh at the old man than to understand his genius. Larguier did his military service in Aix; he was a noncommissioned officer with a squad to drill, and when Cézanne passed in a hired carriage on his way to paint in the country, Larguier would order his men to present arms, as if to a general or a head of state. Gasquet, a native of Aix whose father was a friend and contemporary of Cézanne, became a devoted disciple and took it upon himself to record the master's words and hand them down to posterity. How far the

entranced listener enlarged on what he heard, or interpreted it with the lyrical fervor and fancy so common in Provençal poets, is a matter of opinion. It is not even certain that he did so, but it is quite possible. If he did, it was in sincere obedience to that fidelity of the heart, that devout communion of minds which made him hang on every word which fell from that sacred mouth, much as the budding philosophers of ancient Athens drank in the words of Socrates.

By means of an instinctive discipline of silence and aloofness, Cézanne protected himself against other people, all those who were incapable of understanding or appreciating him—which meant practically all his fellow citizens in Aix and the overwhelming majority of art critics. That protective screen of self-discipline is reflected on canvas whenever he stood before his studio mirror to paint his own face. The most striking of all his self-portraits is one he painted in his early twenties.[1] In it he appears aggressive rather than aloof or elusive—a hunted creature turning on his pursuers and facing them down, with obstinacy in his brow, dark fury in his eyes, and bitterness in the lines of his mouth. Not one of those "character heads" or the "caprices" painted at the same age by the young Rembrandt, in simulated rage or bursting with laughter, but, for the first and last time in the series of Cézanne's self-portraits, a veritable tragic confession. A little on the romantic side no doubt, but this was the beginning of Cézanne's "romantic-expressionist" period of overwrought emotionalism, and he was at the age when a young man is apt to play a part. This attitude is unusual in Cézanne. Never again in the years to come did he pry so curiously into the inner life; henceforth the expression of an individual's private life, whether his own or other people's, was banned from his art. Cézanne, it would seem, deliberately held aloof from those secret places of the heart which Dürer and La Tour

penetrated and explored with so acute an eye and mind that they drew involuntary confessions from even the most reticent and noncommittal sitter. For Cézanne, a portrait, even a self-portrait, was only a certain arrangement of lines, volumes, and colors—a pretext for constructing a definite organic architecture in which the pulse of life is

1 Portrait of Joachim Gasquet, 1896-1897.
Canvas, $25^5/8 \times 21^1/4$ in.
Prague, Narodni Gallery.

2 Man with a Blue Cap (Uncle
Dominique), 1865-1867. Canvas,
$32^1/4 \times 26^1/8$ in.
New York, The Metropolitan Museum
of Art, Wolfe Fund 1951.
(From The Museum of Modern Art,
Lillie P. Bliss collection.)

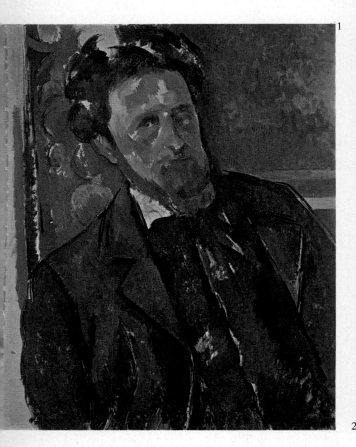

1

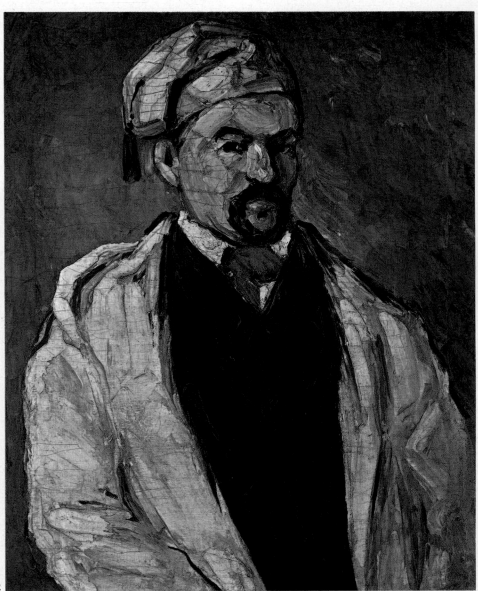

2

3 Sketch of the artist's father and head of
a woman, 1866-1871.
India ink and pencil, sheet $9^1/4 \times 7$ in.
(Chappuis no. 35).
Basel, Kupferstichkabinett.

4 Portrait of Ambroise Vollard, 1899.
Canvas, $39^3/8 \times 31^7/8$ in.
Paris, Musée du Petit-Palais.

gradually checked, and life itself is frozen and congealed. The psychological element, and that intimation of individual destiny which the portrait painter wrests from passing time and records forever, meant no more to Cézanne than the jug or apples of a still life. The problems which beset and tormented him, and for which it took him a whole lifetime to come within sight of a solution, were almost exclusively technical problems. What he aimed at, first and foremost, was to render his inner vision of things; and for his purposes a man contained exactly the same amount of life, no more and no less, as a chair or a fruit dish.

But to conclude that Cézanne was wholly indifferent to psychological analysis would be a mistake. All the powers of his mind and all the resources of his creative passion were concentrated on one thing: expressing that true inner nature of the object which can only be revealed when artist and object interact sympathetically. Single-minded

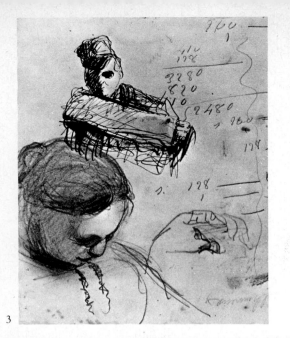

3

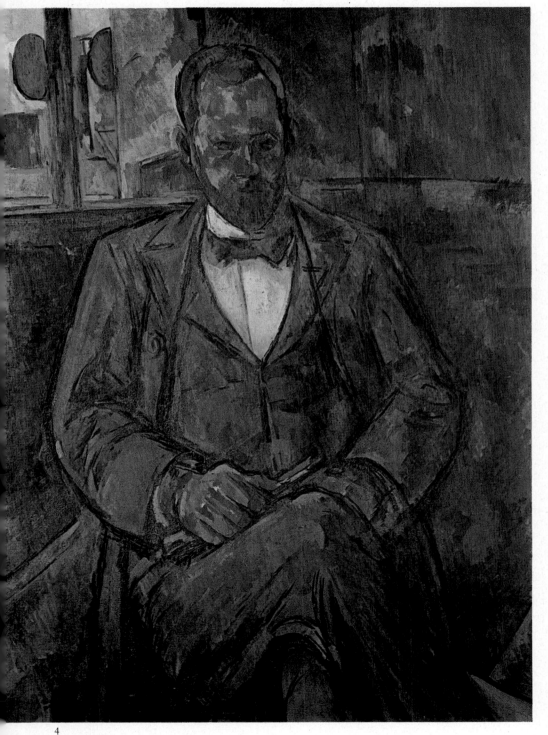

4

he was, but to call him narrow-minded would indicate a complete misunderstanding of the motivations of genius. If the path taken by this particular genius seems narrower than most, this very economy is a token of the highest demands an artist can make on himself, of the most wholehearted dedication to his work. Art is an exclusive and jealous mistress, a calling to which all else must be sacrificed, and the nobility of Cézanne's "obscure life," devoid of interest apart from his work, lies quite simply in the fact that he lived only to paint. What mattered were his working sessions in the open air, *sur le motif*, or in his Aix studios in Rue Boulegon and the Chemin des Lauves. Aside from that, nothing that happened in the ordinary course of life could really touch him. It was characteristic of him that on the day of his mother's funeral he went out painting in the countryside instead of attending the ceremony—not out of gross disregard for man's most elemental feelings, but simply because the act of painting was for him the finest tribute that could be paid to life and death.

One may turn, after that, to accounts left by those who knew him, but on the whole these are not very instructive. His boyhood friend and schoolmate, the man who at one time was closest to him and enjoyed his confidence, shows all too plainly that he never understood Cézanne.

"He is all of a piece, stiff, hard and unbending. Nothing can force a concession from him. If by chance he expresses a contrary opinion and I argue about it, he loses his temper without pausing to consider the matter, shouts you down, and changes the subject" (Zola, in a letter to Baptistin Baille, June 10, 1861). That powerful but coarse-grained novelist had no more insight into the work than into the man himself, whom he persisted in seeing as an "abortive genius" and a "failure." He described him thus in his novel *L'Oeuvre*, whose hero, the painter Claude Lantier, is closely modeled after Cézanne. Publish-

1

ed in 1886, this unfair and uncomprehending book broke up their thirty year friendship. From Gardanne, Cézanne wrote Zola a sorrowful, bleak, stoical letter, and all relations between them then came to an end. For so sensitive and thin-skinned a man as Cézanne, it must have been galling to be lectured to and reproached in such pretentious and misguided terms: "You have no backbone, you hate to go to any trouble over anything, whether in thinking or acting; your guiding principle is to let things slide and to rely on passing time and chance" (Zola, in a letter of 1860). One can imagine the wounds inflicted on the anxious and diffident artist by such blunt charges as these, in which hardly a word was not grossly unjust or false. It would appear that Zola, under the specious pretext of advising and helping his friend, was in fact being disparaging and sneering at him.

The contempt of the successful novelist for the unrecognized painter comes out in a famous phrase: "He may have the genius of a great painter, but he will never have genius enough to become one." The truth is that Cézanne never ceased to grow, year by year becoming an ever-greater painter, so that, just before his death, he could say humbly but honestly: "I am slowly making progress." Thanks to that slow, steady, purposeful growth, he went his way, never swerving from the course he had mapped out for himself, and achieved a greatness wholly and exclusively his own.

Bernard Dorival, in his discerning book on Cézanne, strikes a more telling note when he writes: "How can one help suspecting that his lifelong unsociableness had some deeper cause in the events of his childhood? Wounds inflicted on a child's pride often remain unhealed in the grown man."[2] Behind the complexes that a psychologist might easily detect in his behavior but which, it must be emphasized, did not affect his genius,

two character traits stand out sharply: his timidity and his prudishness. How timid he was is shown by the trouble he always had in communicating with other people (though there were some notable exceptions), the way he hung back and kept to himself, perplexing his painter friends at the Café Guerbois and avoiding human contacts for fear of being hurt or imposed on. And because he was timid and prudish, he kept women at a distance, even the models he needed; not because of what people might say in the narrow, puritanical society of Aix, but because he feared he might somehow be lured away from his total commitment to painting. For this reason he preferred to paint nudes from photographs. The Provençal poet Joseph d'Arbaud told of one day meeting Cézanne, who with embarrassment asked him to obtain some photographs of naked women for him. "It will be easier for you, as a young man, than for me," he added with a blush. So there were very few women in his entourage, apart from Hortense Fiquet, whom he finally married, after she had been his mistress for some years and had given him a son.

No life was as barren as his of those "great events" which, in some cases, spur an artist on and, in others, cripple or paralyze his efforts.[3] Deliberately or instinctively, he kept out of the way of stormy passions, of any kind of passion, and once the impetuous longings of youth were past, he remained faithful to his vocation. His life does not appear to have been disturbed by any metaphysical qualms or mystical fervor. He regularly attended Mass in the cathedral of St-Sauveur in Aix, and his spiritual life extended no further than that.

His biography, then, is remarkably uneventful and can be summed up in a few lines. Its main features are all closely connected with his painting; apart from that, there is little to record. He was born into a well-to-do, traditional-minded family in Aix-en-Provence on

January 10, 1839. His father, a hatter who became a successful banker, was at first uneasy at seeing his son run the risks of an artistic career, but he resigned himself to it and assigned him an allowance which enabled the young painter to work in freedom and security, without the money worries that plague so many artists. Thus, Cézanne never had to earn his living; he always had an adequate allowance from his father, and after the latter's death in 1886 he found himself a rich man. This financial independence, which seems to be a prime condition for the unimpeded development of genius, shielded

2

Cézanne from the often tyrannical demands of dealers and buyers.

He received a good classical schooling in Aix and studied law for several years at the local university, until a day came when his passion for painting won out and he could no longer afford to waste time preparing for a profession he did not need or want to follow. He had been taught drawing and the rudiments of

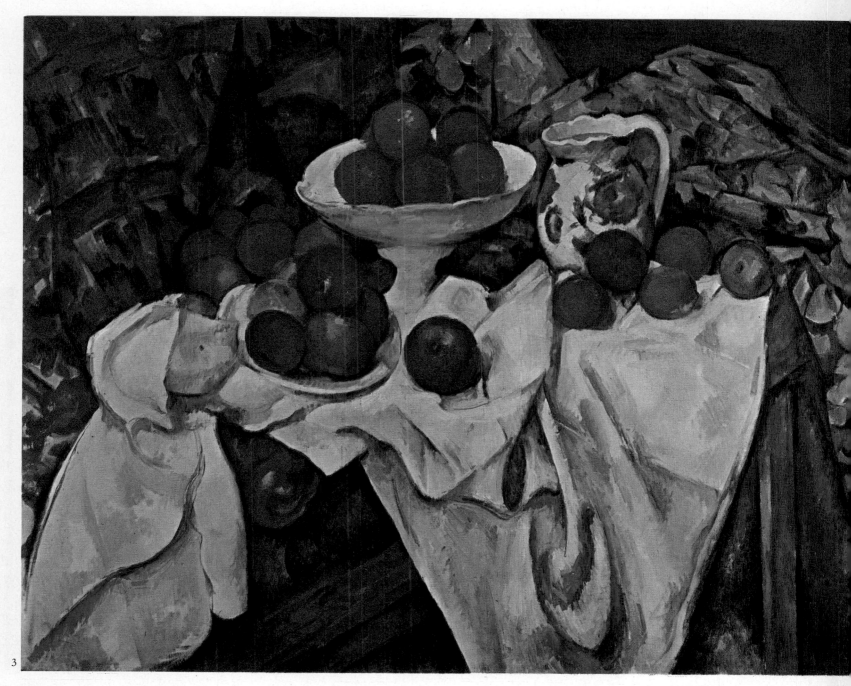

3

painting by Joseph Gibert[4] at the School of Fine Arts in Aix, where he studied while waiting for an opportunity to go to Paris—the ambition of all young provincials in France. Zola, already in Paris and already making a name for himself as a journalist, writer, and art critic, wrote long letters to Cézanne urging him to come and join him.

With his father's consent, Cézanne made his first stay in Paris from April to September 1861. He seems to have admired indiscriminately the masterpieces in the Louvre and the star attractions at that year's Salon, Cabanel and Meissonier. He went back to Aix to ponder on these experiences; there, discouraged by his own lack of progress, he accepted a job in his father's bank. He had early come up against the closed doors that were to meet him all his life: he had been refused admission to the École des Beaux-Arts in Paris, and had to be satisfied with working in a private studio, the Académie Suisse, near Notre-Dame. Later his work was refus-

ed at the Salon. For years, almost till the end of his life, he met with blind incomprehension from the public, dealers, and critics; even his friends doubted whether he had the makings of a real artist.[5] During the 1860's he divided his time between Aix and Paris, where he fell in with the young painters with whom he had most in common: Monet, Sisley, Guillaumin, Bazille, Renoir, and Manet. He frequented the literary cafés, especially the Café Guerbois, where the artists met and talked in the evening; but, more accustomed to solitude, he was not in his element there.[6] Though

he twice exhibited with the Impressionists, he never shared their outlook or technique; the priority he gave to the expression of *sensations* set him apart from the true Impressionists, who were intent on purely visual effects. Émile Bernard understood this when he said: "Far from being spontaneous, Cézanne is deliberate. His genius is a flash that goes deep."[7]

This may help us to understand what Cézanne himself meant by his famous remark to Joachim Gasquet: "Sensations are the basis of everything for a painter." This pronouncement can be misleading,

however, for it represents only one side of the artist's personality, only one aspect of his technical and aesthetic approach to the art of painting; it has to be completed and corrected by another quotation, which makes it clear that Cézanne insisted on the need to *know* as well as *feel*. Here, as recorded by Joachim Gasquet, is the key phrase, which provides the soundest basis for any study of his work: "Yes, I want to know what I'm doing: to know, the better to feel; to feel, the better to know. I want to be a classical painter, to become classical through nature."

More will be said about this point later on, when we come to deal with Cézanne's admiration for Poussin and the true nature of his "sensations" compared with those of the Impressionists, with whom he was temporarily associated. But the main landmarks in his career should be borne in mind. First came his decisive and fruitful friendship with Pissarro, without whose guidance his genius might never have evolved just as it did. In 1874 they worked together directly from nature in and around Pontoise and Auvers-sur-Oise, in the Île-de-France countryside northwest of Paris. Cézanne gratefully acknowledged his debt to Pissarro, who was for him "something like God the Father."

In 1874 the first group exhibition of the Impressionists took place, and the first clash with a hostile public. The critics were blind to the freshness and novelty of their work, and Cézanne's canvases in particular were held up to ridicule. Three years later, in 1877, his pictures hung beside those of Monet and Sisley at the third Impressionist exhibition and again aroused laughter and indignation. After that, exhibitions of his work were few and far between. In 1890 he was invited to show in Brussels with the group known as "Les Vingt." In 1895 his first one-man show was organized by Ambroise Vollard, the first dealer to appreciate his work and promote it. He took part in the Salon des Indépendants in 1898 and 1899. At the large Centennial Exhibition in Paris in 1900, he had the honor of seeing three of his canvases included in the retrospective of French art.

Little by little, signs of general recognition were forthcoming. Cézanne became a regular exhibitor at the Salon des Indépendants, showing there again in 1901 and 1902. At the Salon d'Automne in 1904 a whole room was devoted to his work. But he never realized his odd, lifelong ambition of seeing his work accepted at the official Salon (the "Salon of Bouguereau," as he called it,

after an arch-academic of that day), where his genius would certainly have been out of place. That he yearned for acceptance there shows both the characteristic modesty of the man and the awareness he had of the high quality of his work, in spite of recurring doubts.

In mid-October 1906, while painting in the open countryside (as he continued to do every day, though suffering from diabetes), he was caught in a violent rainstorm and drenched. He tried to get home but collapsed by the roadside. Picked up by a passing laundry cart and brought back to Rue Boulegon, he died a few days later, on October 22. In the nearly seventy years since his death, many honors have been paid to Cézanne, and his influence on subsequent painting has been momentous. It is not too much to call him the father of modern art, for there are few subsequent movements that do not owe him something. His achievement is so rich that almost every later artist has derived some benefit from it.

Georges Rivière, one of the first critics to understand and admire him, was right when he described him as being "of the race of giants." After seeing the exhibition at Vollard's in 1895, the writer and critic Gustave Geffroy, of whom Cézanne painted one of his finest portraits, said: "He will go to the Louvre"—something which Cézanne in his own wildest dreams would never have believed possible. For him, the Louvre was the home of the old masters he revered, and he would have been happy enough to be accepted at the "Salon of Bouguereau." But before Geffroy's prophecy could come true, Cézanne had to live out an ascetic life from which everything unconnected with painting seemed to be banned. Appropriately enough, Paul Sérusier described him as "the pure painter," and Octave Mirbeau referred to him as "the most painterly of all painters."

But to be a pure painter, it was not

enough for him to follow his calling single-mindedly. He had to become a pure painter through all the vicissitudes of a life into which many disparate influences entered: Manet, Courbet, and Delacroix in his early days, then the Impressionists at the first major turning point of his career. But from the time of that turning point, Cézanne came to realize he would have to rely on himself, on his own powers and innermost resources, in order to achieve his purposes. And so from the solitary evolution of the most original artistic genius of the nineteenth century sprang everything that was to lay the foundations of modern painting in the century to come. Choosing loneliness and seclusion in the interest of his work, this man who was the source and fountainhead of so much of the art to come virtually cut himself off from the world. Perhaps for that very reason, what he tells about himself in his letters and recorded statements does not seem very significant; and the accounts given by his biographers are not very enlightening. In spite of all that has been said and written about him, he remains a mysterious and impenetrable figure, with something about him, as René Huyghe put it, of the "strange fascination of a myth."[8]

To the realities behind that myth, there is only one key: his work.[9] Many things of interest and importance have been said in the attempt to analyze and elucidate that work, but they are only approximations. As such, these are of course indispensable in formulating a human approach to him. (One hardly dares say a *philosophical* approach, for that word seems alien to Cézanne, and access to his inner life appears to be blocked by the defenses he raised around it.) But the fact is that, however detached it may seem from the man himself, his work, as Kurt Badt pointed out, must be seen for what it is: a great confession.[10] Badt goes on to define the core of that confession: "Its starting

19

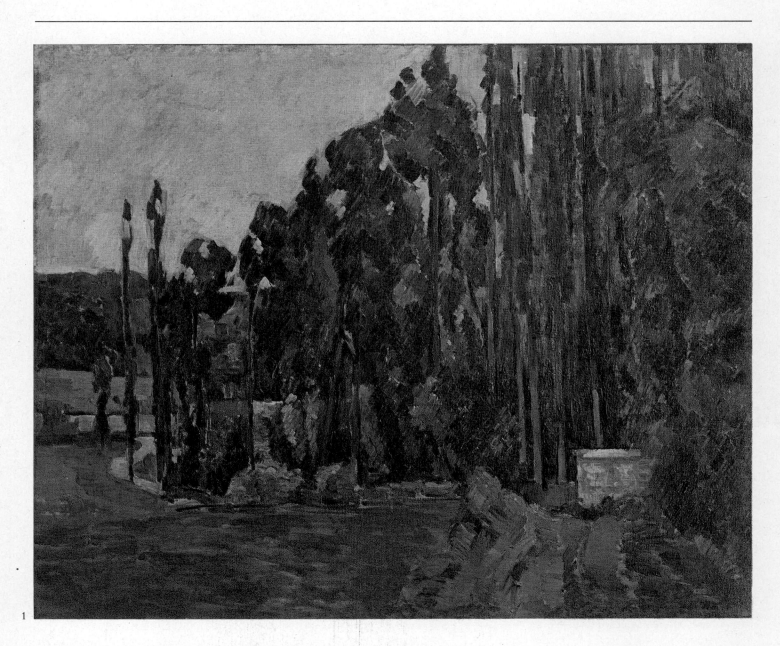

1

1 Poplars, 1879–1882. Canvas, 25⅝ × 31½ in. Paris, Musée du Louvre. (Photo Josse)

2 View of Auvers, c. 1880–1885. Watercolor, 9 × 11¾ in. Private collection.

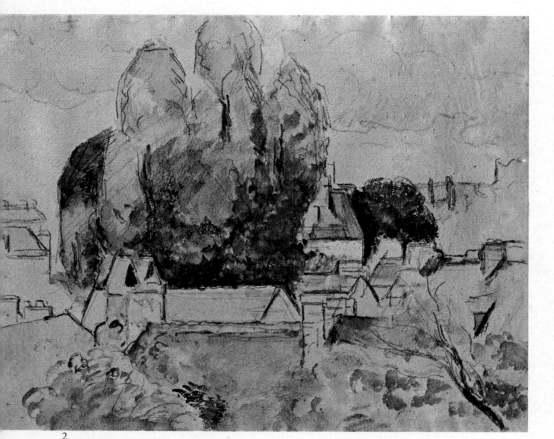

2

point, in the characteristic manner of the nineteenth century, lay in the artist's suffering and his triumph over that suffering." Untold sufferings and an unsung triumph, for like all true Provençals (it is an utter misconception to regard them as excitable and talkative) Cézanne possessed a great capacity for silence. He possessed, as Gauguin astutely noted, the tranquillity of a man who has lain down to sleep. In this silence and self-communion, the work to which he gave all the strength he had slowly grew, like a fetus swelling the body of a pregnant woman. His biographers have recorded an expression that often fell from his lips: "Life is frightening!" A long commentary would be required to explain the nature and implications of that "fright," not so much in his attitude to life as in the effect of that attitude on his work. It seems to lie behind the fits of moodiness

and dejection that came over him so unpredictably in his youth, in the days when he still opened his heart in letters to his friends. Typically Provençal, that moodiness was also distinctive of an earlier artist from this region, the greatest Baroque artist produced in France, and perhaps the only truly Baroque artist of seventeenth-century France: the sculptor Pierre Puget (1620-1694). The "struggle with the Angel" which Puget carried on all his life—and in which he felt victorious only when he could say at last, with a humble pride reminiscent of Cézanne: "The marble trembles under my hand" —prefigures the exhausting, unremitting struggle carried on by Cézanne day after day, year after year, until the eve of his death, when the brush fell from his hand.

"There is a sadness about Provence that no one has described," he once told Gas-

quet.[11] In saying that, he showed true insight into his native region. But there is an important qualification: the sadness of Provence is not passive and deadening; on the contrary, it is dynamic and invigorating, and spurs a man to action. Cézanne effectively overcame and dominated that melancholy in his first outstanding works, those of his youthful period best described as "romantic-expressionist."

But the young Cézanne was a romantic in spite of himself, and he seems to have been ashamed of it. In 1900, two years before Zola's death, Gasquet questioned him about the friend of his youth and the novelist said: "In his early days Cézanne used to get furious at the romantic canker that, do what he would, kept flourishing within him. That was his disease, or perhaps just a false idea that hung round his neck like a millstone." Once again Zola shows that he did not understand the artist and misinterprets him. This early phase, in the 1860's, is usually known as his "dark" period. Cézanne called it his *couillarde* period, meaning vigorous, bold, hearty, or daring. In other words, it was a period when he gave free rein to his temperament, being as yet indifferent to the strict discipline he later imposed on himself. In those years, his was a temperament full of youthful violence and lusty animal spirits, naïvely reveling in crude exaggerations and overemphasis. His early canvases are marked by an explosive sensuality and a reckless, exuberant revolt against the academicism of the Salons that rejected him and against the bourgeois conventions of provincial society in Aix. He released his feelings with a vengeance. Aesthetically and technically, this early work follows in the wake of Manet, Courbet, and Delacroix; yet it has a rugged power that owes little or nothing to those masters. In its full-bodied volumes and dark, heavytextured pigments, it rises at times to a formidable intensity. There was an overflow here of the un-

1

conscious mind, with an obvious power of visionary expression.

But if we consider a more technical point—the way in which space is conveyed and organized—we already find among these pictures some remarkable examples of architectural composition, showing a sure sense of sound design and construction and anticipating in this respect the later work of the Gardanne period. Among his early canvases exemplifying this structural sense are *The Autopsy* and *Pastoral* (sometimes known, oddly enough, as *Don Quixote on the Barbary Coast*). These pictures and the whole question of Cézanne's handling of space have been ably studied by Liliane Guerry (*Cézanne et l'expression de l'espace*, Paris, 1950). His structural patterns stress volumes and create an undercurrent of dynamic rhythms which quicken even his most static compositions.

The pent-up feelings of the young Cézanne and the turmoil of his spirit found release in *The Thieves and the Donkey* (also called *Sancho Panza*); *A Modern Olympia* (one version in the Lecomte Collection and another, slightly later version in the Louvre); *The Orgy* of 1864-1868; *Afternoon in Naples, Rum Punch,* and *The Descent into Limbo*. These, together with the pictures already mentioned, are the major works of his early "dark" or romantic, period. These are figure compositions of pure imagination which, in a certain sense, may be described as visionary. The figures are static, unmoved by the stormy climate of passion in which the painter unleashes his surplus energy. But that immobility is compensated for by the sheer expressive power of the paints, which comes through even in pictures of the simplest design, such as *The Negro Scipio* and *The Penitent Magdalen*. The violent surge of the pigments, laid on in broad sweeping strokes or abrupt, twisting slashes, commands attention. The pure colors, piled on in a thick impasto and clashing with each other,

swelling and throbbing with life, seem like the work of an overexcited Delacroix. They anticipate by nearly half a century the bold expressionism of Die Brücke.

Sometimes the subject is devoid of dramatic significance. Such is the case with *The Rape, The Abduction,* and a number of ingenuously ribald pictures on erotic themes, whose figures are nevertheless handled with an emotional vehemence that would be more suitable to a tragic theme. Some of these figures have the solidity of a Romanesque column-statue. Outstanding among his early portraits are those of *Achille Emperaire* (Louvre) and *Uncle Dominique*, a brother of his mother, whom he painted twice, as a monk and as a lawyer (Haupt Collection, New York; Private collection, Switzerland). Powerfully modeled with the palette knife, as if done with a trowel, these faces satisfy the requirements of purely pictorial design. Standing like rocks weathered by the elements or thrown up by some subterranean upheaval, they furnish no occasion for psychological analysis.

The figures portrayed by Cézanne show no more evidence of passion, emotion, or ideas than the objects that go to make up his still lifes of the dark period, such as the *Black Clock* (Niarchos Collection, Paris) or *Stove in the Sudio* (Collection of Chester Beatty, London). But these objects are astonishingly alive, more so perhaps than the figures, and Guerry has emphasized this "strange paradox": "While the girl at the piano and her companion have the immobility of inanimate objects, the stove, kettle, and clock rise before us, like living creatures. If it were not held down by a heavy cauldron, the stove with its fanciful feet would, one feels, start moving toward us like a spiritualist's table at a séance." Figures and objects seem to exchange their properties, powers, and attributes. The changeover from animate to inanimate, and back again, is here an operation of pure painting, carried out

as part of a thoroughgoing renewal of the very conception of form and space, and of form *in* space. This process, largely intuitive at this stage, can be seen taking place simultaneously in his imaginary compositions, portraits, and still lifes.

But what about landscape painting? What role did it play in this imposing ferment of forms? There are a few outstanding landscapes of this early period: *Factory near Mont Sainte-Victoire* (Bührle Collection), *Melting Snow at L'Estaque* (Wildenstein Collection, Paris), and especially *The Railway Cut* (Bayerische Staatsgemäldesammlungen, Munich), "his first masterpiece."[12] But there is nothing to compare with the great landscapes of his Impressionist period, which lay just ahead, or of the later "constructive" period—to say nothing of the superb late view of Mont Sainte-Victoire that were to crown his career as a landscapist. But an important development was at hand. When the Franco-Prussian War broke out in 1870, Cézanne was called up; but he ignored the summons and took refuge at L'Estaque, an out-of-the-way village on the Mediterranean coast near Marseilles, where he went on working undisturbed. He did not return to Paris until 1871, when the convulsions of the Commune were over and political passions had begun to subside. He himself was indifferent to all political and social matters, for his one concern was with painting. He found the seaside landscape at L'Estaque as majestic and fascinating as the environs of Aix, with the severe, clear-cut outline of the hills and the subdued grayish-blue of the sea. "It is like a playing card," he later wrote to Pissarro (in 1876). "Red roofs against the blue sea. The sun is so strong that objects seem to be silhouetted, not only in black and white, but in blue, red, brown, and violet."[13]

This limpid, forthright landscape, with its compact volumes and elemental colors, released him from the grip of that

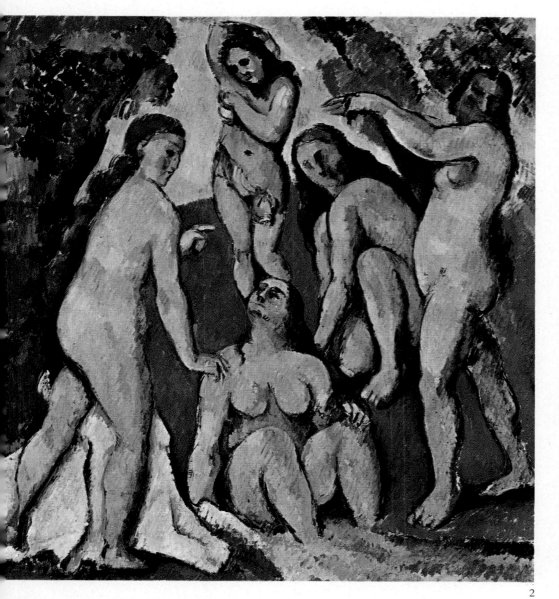

overwrought emotionalism which had possessed him during his romantic-expressionist period. His way of seeing became less visionary, his contact with nature simpler and more direct; witness such a picture as *Fishing Village at L'Estaque* (Pellerin Collection). It is a "classical" landscape, in the sense given to this term by Cézanne, whose avowed purpose in later years was "to do Poussin over again from nature." To Chocquet he once wrote (June 1886), "The boundless things of nature attract me." His longing for the unlimited might well have drawn him away from classicism, which signifies moderation. What saved him was precisely this sobriety of the Provençal landscape. Gasquet's poetic enthusiasm, which occasionally irritated him, may have exaggerated what Cézanne told him: "The great classical landscapes, our Provence and Greece and Italy as I imagine them, are those where light is spiritualized, where a landscape is a smile flickering with keen intelligence." But the meaning is clear, and it is characteristic of Cézanne. Characteristic of him, too, is that closeness to nature peculiar to the Provençals, as heirs of the Ligurians, Greeks, and Romans, which may not be very evident in his early work but which was soon to find fitting expression, for Cézanne was now ready to profit from what could be learned by an encounter with Impressionism.

2

1 Studies of bathers, 1872-1877. Pen and pencil, sheet $7^7/8 \times 11^7/8$ in. (Chappuis no. 98). Basel, Kupferstichkabinett.

2 Five Bathers, 1885-1887. Canvas, $25^3/4 \times 25^3/4$ in. Basel, Kunstmuseum.

From impressionist naturalism
to constructive design

The Negro Scipio, c. 1866.
Canvas, 42¹/₈ × 32³/₄ in.
São Paulo, Museu de Arte.

1 Portrait of Anthony Valabrègue, c.
 1868. Canvas, 45⁵/₈ × 38⁵/₈ in. U.S.A.,
 Private collection.

2 Study for the "Portrait of Achille
 Emperaire," c. 1868. Charcoal and
 pencil, 19¹/₄ × 12¹/₄ in. Paris, Musée du
 Louvre, Jeu de Paume.

3 Portrait of Madame Cézanne,
 1872–1877. Canvas, 21⁵/₈ × 18¹/₈ in.
 Private collection.

Cézanne was never an Impressionist in the way that such artists as Monet and Sisley were; their approach and technique were always foreign to him. From the time of his first contacts with the Paris art world in the 1860's, the only painter he felt anything in common with was Camille Pissarro, whose outlook and aspirations resembled his own. So in January 1872 he was only too glad to join Pissarro at Pontoise, not far from Paris. The landscape and light were very different from what he was used to in Provence, but his eye readily adapted itself and his palette soon brightened as he painted in the open air with Pissarro. For a long time to come, he modestly described himself as the latter's "pupil." "We all stem from Pissarro," he said, and to some extent it was true, for if Cézanne became the "father of modern art" it was due in part at least to the guidance of Pissarro, whom he called "God the Father." "Never paint with anything but the three primary colors and their immediate derivatives," Pissarro told him. No ochers, no bitumen, no sienna, no black. Cézanne was too fond of the rich effects of black to eliminate it entirely from his palette, but he began to abandon dark colors and his canvases grew much brighter as his eye became more sensitive to the play of light and the shimmer of tones under its impact.

His way of painting also changed. Subduing his impetuosity, he worked now in small brushstrokes, carefully applied one beside and over another until he obtained the desired effect. There was nothing here of the instinctive, vibrant touch of Monet or the scientific divisionism practiced by Seurat, but a cautious and thoughtful build-up of tone and touch, the forms being shaped with his brush. The sweeping and impetuous strokes of his earlier work gave way to a controlled mosaic of color on several levels. This is why he worked so slowly. After one hundred and twenty sittings for the portrait of Vollard, he grudgingly admitted he was "not

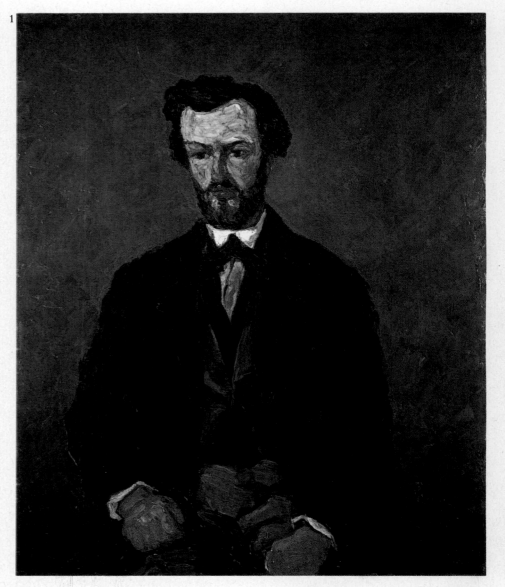

dissatisfied with the shirt front." For his still lifes he had to use paper flowers, because real flowers withered before the picture got very far. But this was a theme to which he often returned in the 1870's: *Delftware Vase with Flowers* (Louvre), *Geraniums in a Pot* (Lewisohn Collection, New York), and *Vase with Tulips* (Collection of Chester Beatty, London). The early 1870's were a decisive moment for him. There may be an element of southern exaggeration in his own comment: "Until then I wasted my life." But if he succeeded now in "setting himself free from an inner

nightmare" (his own words) and sublimating the turbulent eroticism that troubled him before, he owed it to his new surroundings and new mentor, to a new way of seeing and new methods of work. In order to break Cézanne of the habit he had of abruptly abandoning his picture whenever dissatisfaction and doubts came over him, Pissarro obliged him to paint entirely in the open air and not to leave the motif until his canvas was finished. The result was that his canvases gained a new freshness and immediacy, a genuine naturalness that is inevitably lost, or at least impaired,

when plein-air scenes are worked over afterward in the studio. Truth to nature became his guiding principle. At Pontoise in 1872 and at nearby Auvers in 1873 and 1874, he pursued his experiments, his re-education of hand and eye, which showed up not only in his landscapes but also in portraits, still lifes, and figure compositions. Among the latter, nevertheless, there were still many that sprang from visionary imagination, not from objective vision.

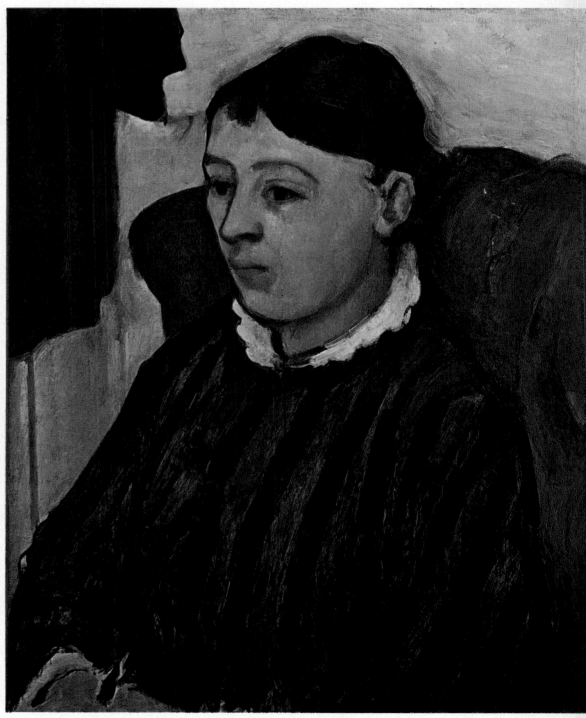

2

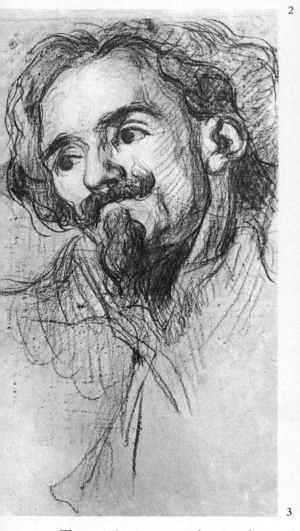

3

The most important are the second version of *A Modern Olympia*, a watercolor in the Stern Collection, *Lutte d'Amour* (Collection of Mr. and Mrs. Averell Harriman), the best version of his *Temp-* *tation of Saint Anthony* (Lecomte Collection), *Luncheon on the Grass* (Pellerin Collection), and the curious scene entitled *The Thieves and the Donkey* (or *Sancho Panza*; Wildenstein Collection, Paris). Now, too, he painted a *Male Nude* (Mueller Collection) and, between 1872 and 1878, his first studies of "Bathers," a theme which he continually adopted and modified and which culminated in

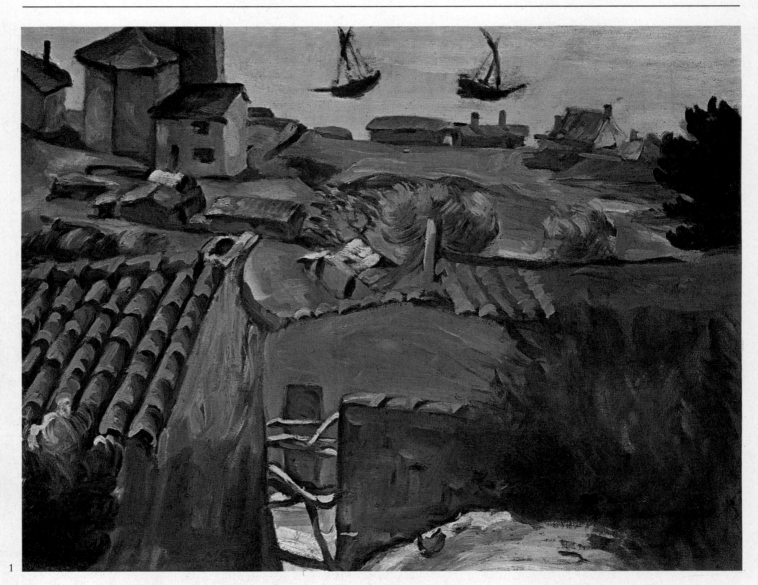

1

the large "Bather" compositions of 1900-1905. In all, he produced forty-two variations on this theme (not counting the sketches), which raised one of the problems that most deeply interested him: representation of the nude figure outdoors, amid nature and in broad daylight, not within the four walls of the studio with its romantic, expressionistic lighting effects.

Though uneasy and nervous before the human face, just as much as he was before the naked body of a man or woman, Cézanne brought to the portrait all the enrichment he had gained from his contacts with Impressionism. The masterly portrait of *Victor Chocquet* (Rothschild Collection) of 1877 figured in the third group exhibition of the Impressionists held that year, where its bold colors and even bolder brushwork excited the hostility and indignation of the public. This work retains the monumental power of the portraits of his dark period, despite a novel use of color and a brighter palette. This sense of monumentality brings to mind Egyptian sculpture at its most massive and impressive. It gives a sober grandeur to three portraits of *Madame Cézanne—* sewing (Rosenberg Collection), wearing a striped dress (Private collection), and with a fan (Bührle Collection). The background of these pictures is not a mere backdrop but is organized as an integral part of the whole, by being closely knit together with the volumes of figure and objects. Every element— the wallpaper patterns, a dash of color in the clothes, the overlapping facial planes— contributes to the cohesiveness and solidity of a pictorial architecture over which there play patches of light that lend an impression of fleeting life to the motionless figure, captured forever in its

28

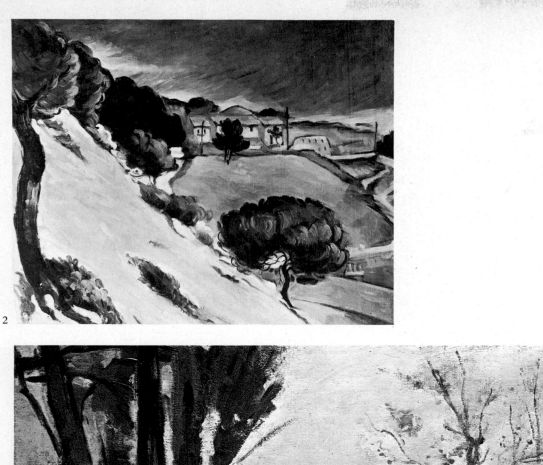

2

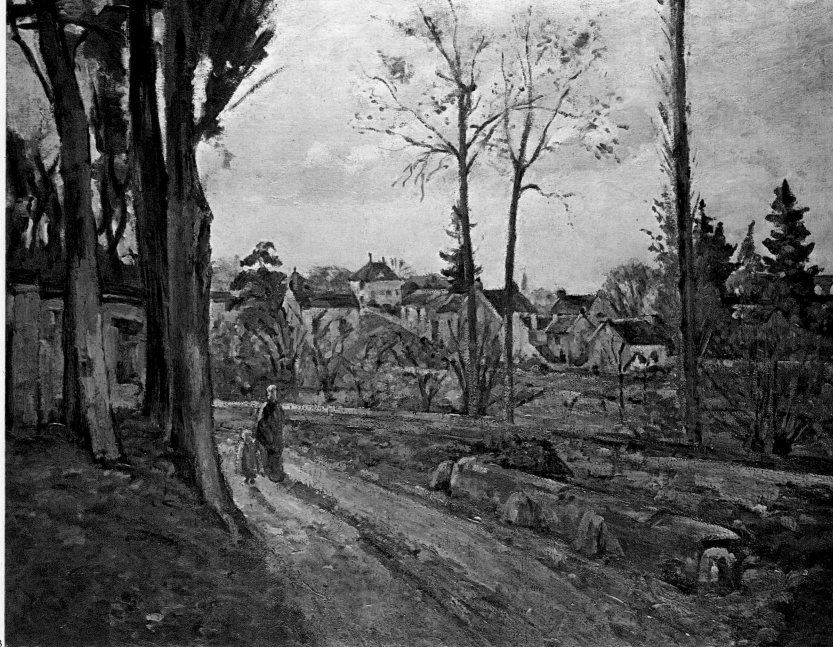

3

very essence by the artist. Much the same may be said of *Self-Portrait with Pink Spots* (Lecomte Collection). As commented upon by Liliane Guerry: "The pink spots (on the wall) are conceived as a necessary accompaniment, vital to the cohesion of the different elements which go to make up Cézan-

ne's face.

In their design, moreover, if looked at closely, those spots form an almost identical replica of his face. These light pink clouds on a gray ground even pass over his face, breaking it up into darker and lighter patches and lending it that fitful and sulky expression."

A similar process can be observed in his *Self-Portrait with a Hat* (Kunstmuseum, Bern): the integration of the figure into its surroundings, the sympathetic identification of the living man and the inanimate setting. The way in which the figure merges with the walls and the surrounding atmosphere reveals the

1 A Modern Olympia, 1872-1874. Canvas, 18¹/₈ × 21⁵/₈ in. Paris, Musée du Louvre, Gift of Paul Gachet.

2 The Eternal Feminine, 1875-1877. Canvas, 17 × 20⁷/₈ in. U.S.A., Private collection.

3 Study for "The Afternoon in Naples," 1872-1876. Pencil, sheet 3⁷/₈ × 8¹/₈ in. (Chappuis no. 70). Basel, Kupferstichkabinett.

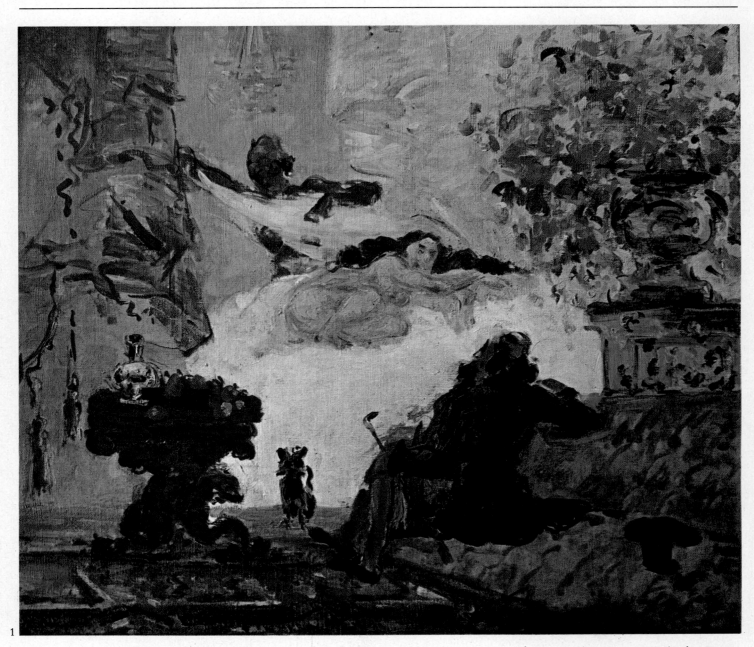

1

identical nature attributed to them, the equal value assigned to figure and object. This indifference to any distinction between animate and inanimate makes the face almost as blank and sturdy as a wall, despite a hint of melancholy that is somewhat surprising here, where the painter does succeed in conveying a faint quiver of inner life, a shy and yet touchy expression, while anxious not to give away any personal secrets—which

is already a confession in itself. Compared with the Bern picture, *Self-Portrait with a Cap* (Leningrad) retains some of the theatrical lavishness of the romantic-expressionist period, resulting from an emphasis on accessories, which, as always with Cézanne, are not added for any picturesque effect but as a means of modulating the lights and shadows of the face. Thus in the Bern self-portrait the volume and colors of the hat

play a very important part in the structure of the picture. In the Leningrad self-portrait the cap rounds off the elongated face, built up on a vertical axis which supports the weight of that "heavy, plastic, perfectly stable mass" which Guerry has also noted in the *Self-Portrait* in Munich (Neue Staatsgalerie). Color modulation now replaced the strong contrast of light and shade which had characterized the romanticism of his

30

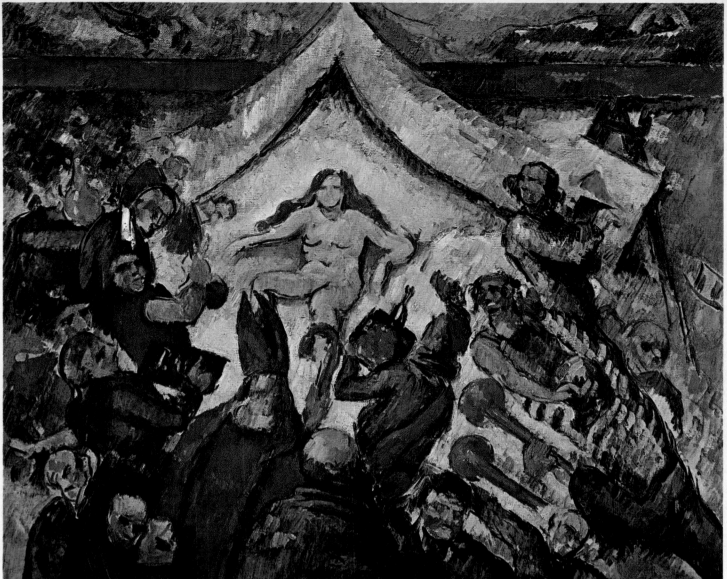

2

youth, when he seemed to see the world in terms of a struggle between darkness and light. This modulation of colors is more apparent in landscape than in portraiture and still life, because there his contact with nature was closer and more

a momentary effect; he recorded enduring form.

The most famous canvases of his Auvers period—the *House of Père Lacroix* (National Gallery of Art, Washington, D.C.), the three versions of *Doctor*

3

determinant. Working in the open air, directly in front of the motif in its natural atmosphere, Cézanne learned from the Impressionists to use bright colors and to apply them in small brushstrokes suggesting the intensity of sunlight. But the Impressionists were concerned with capturing fleeting surface effects, impressions, while he was intent on grasping the basic underlying forms of visible objects. They recorded

Gachet's House (Louvre; Kunstmuseum, Basel; and Ryerson Collection, Chicago), and *Snow Effect near Auvers* (Josse Bernheim Collection)—avoid the glitter and "atomization" of light which characterize Monet's pictures of Rouen Cathedral and which make the façade seem so ethereal, unreal, and almost like a mirage. In Cézanne's hands, the landscape is not reduced to a shimmering play of iridescent colors in which the

substance of things seems to melt away and dissolve. With him, the substance of foliage is as solid as that of houses; even the sky and clouds come to life, instead of being suffused with an atmospheric haze. His *Poplars* (Louvre) suggests the vibrancy of wind and light, yet preserves, beyond the flickering changes of the moment, an elemental permanence that nothing can change, an essence that Cézanne has grasped.

Thus, even before his "constructive period" began, Cézanne had gone far to achieve the ambition he later defined in a famous phrase: "to do Poussin over again from nature." In this respect, though nearer to them in time, Cézanne was further from Manet, Courbet, and Delacroix than he was from Poussin, for the latter's classicism had much in common with the attitudes of Cézanne. This is obvious from such pictures as *The Farmyard* (Louvre), *View of Auvers from Val Harmé* (Kunsthaus, Zurich), and above all the famous *Hanged Man's House* (Louvre).

The compositional structure of the *Hanged Man's House* confirms Cézanne's architectural vocation, at the very time when the Impressionists were beginning to reconsider their methods and aims. The view is blocked to the right and left by two imposing masses, and in between these the eye is allowed only a glimpse of the neighboring houses and distant hills. The sky is reduced to

1

a narrow band of space, and even the light itself takes on a certain solidity. The geological nature of the elements is preserved here in its full integrity. This canvas, already reminiscent of Poussin in its classical spirit, is distinguished from Cézanne's pre-1872 landscapes by several innovations: the separate, unblended brushstrokes and brighter colors characteristic of Impressionism, and the movement imparted to objects by the play of the brush and the tonal harmonies.

At one time Cézanne described himself as working by instinct, guided by the spontaneous promptings of his genius, as when, toward the end of his life, he said he painted "as an almond tree blossoms."[14] At other times he confessed that the painting of a picture was an infinitely laborious process for him. These two sides of his personality were in fact equally strong, and in this Pontoise-Auvers period during the 1870's they were most closely in line with each other; his *structural* side and his *instinctive* side each played its part. Nevertheless, the change made by Impressionism in his palette and way of seeing was accompanied by persistent doubts that undermined the self-confidence he needed and tried to gain, but which was more apparent than real. The abuse and ridicule heaped on him by the critics as soon as he began to exhibit, in 1874,[15] pained and discouraged him—and he was only too prone to discouragement. He felt sure of himself only with his mentor Pissarro, with much younger friends, or with chance visitors whose sincere esteem moved and touched him. He sold very few pictures. The allowance his father gave him was not always enough to cover his needs, though he lived simply, even austerely, so that he gave several pictures to a grocer in Auvers to settle bills he could not pay. He was denied any recognition as a painter, and an impressive collection of misjudgments, sarcastic remarks, and insults could be compiled from the comments of contemporary critics and writers on his work.

From April 15 to May 15, 1874, the first group exhibition of the Impressionists was held in the studios of the photographer Nadar, with pictures by Degas, Monet, Guillaumin, Renoir, Sisley, Pissarro, Cézanne, and others—thirty exhibitors in all. It was a complete failure. Manet had refused to join them, and he again held aloof in 1875 when, in a further attempt to arouse interest in their work, the Impressionists organized an auction sale of their pictures at the Hôtel Drouot; it too was a fiasco. In

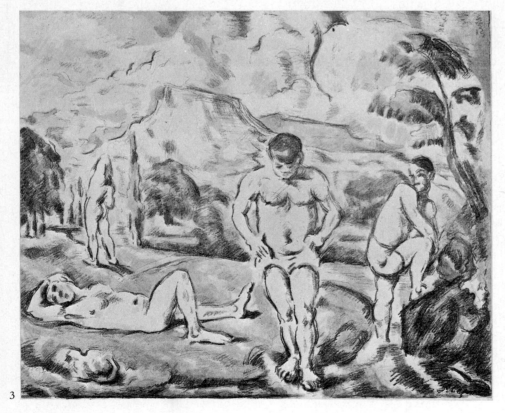

2

4

1 Nudes on the Shore, c. 1870.
Watercolor, $5^{1}/_{4} \times 9^{7}/_{8}$ in.
France, Private collection.

2 Studies of bather, two wrestlers, and
head of the artist's son, 1870–1878.
Pencil, sheet $7^{1}/_{8} \times 10^{3}/_{8}$ in. (Chappuis
no. 83).
Basel, Kupferstichkabinett.

3 The Large Bathers, 1875–1876.
Canvas, $15 \times 18^{1}/_{8}$ in.
London, National Gallery,
By courtesy of the Trustees.

4 Bathers, 1872–1877. Charcoal sketch.
Collection of M. & Mme. Grilichess.

3

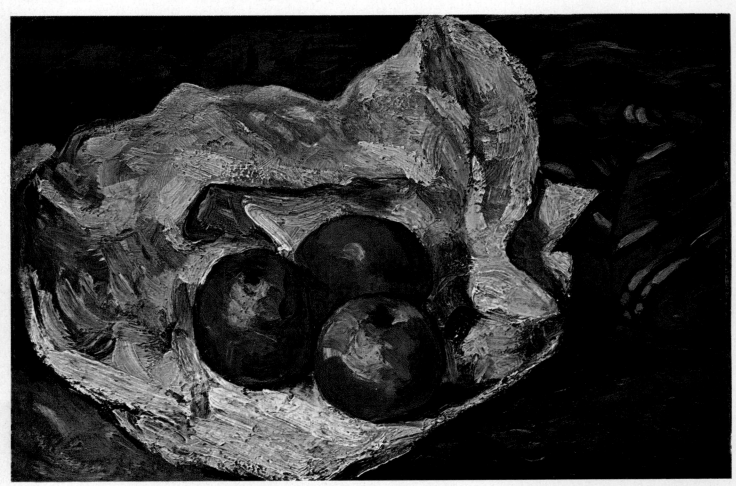

1

1 **Three Apples, c. 1872. Canvas,
9⁷/₈ × 14³/₈ in.
Private collection.**

2 **Still Life with Urbino Vase, 1873.
Canvas, 18¹/₈ × 22¹/₂ in.
U.S.A., Private collection.**

3 **Apples and Biscuits, c. 1877. Canvas,
15 × 21⁵/₈ in. U.S.A., Private collection.**

1876 a second Impressionist exhibition was held, in the Galerie Durand-Ruel. (This time Cézanne did not take part.) This was no more successful than its predecessor. The Parisian public remained hostile to a new form of art it could not understand. A few critics, however, began to look with sympathy at the Impressionist canvases as their eyes grew accustomed to them. Théo-

dore Duret, Edmond Duranty, and Georges Rivière came to the defense of this revolutionary art, and the Impressionists indeed needed defenders when their third exhibition took place in 1877. On that occasion Cézanne exhibited seventeen canvases, which excited general hilarity and, in some visitors, even a sense of outrage. One reviewer, Louis Leroy, warned his readers with mock solemnity that the sight of Cézanne's portrait of Chocquet might be dangerous for a pregnant woman: "This peculiar-looking head, the color of an old boot, might give her a shock and cause yellow fever in the fruit of her womb before its entry into the world." Such was the tone of supercilious banter adopted by all those critics who deigned to review the exhibition.

By contrast, the young Rivière displayed remarkable insight and discernment. "Cézanne," he wrote in his paper *L'Impressionniste*, "is a painter and a great painter. ... His still lifes, so beautiful and so accurate in their tonal relations, have something solemn in their truthfulness. In all his pictures this artist moves us, because in front of nature he himself feels a strong emotion which his skill transmits to the canvas." Rivière, moreover, wisely cautioned the public against mistaking Cézanne's intentions and blaming him for "imperfections which are in fact a refinement obtained by an immense outlay of skill."[16]
After the rebuffs he had met with, Cézanne preferred to withdraw and took no further part in the Impressionist exhibitions. He worked on alone, in the

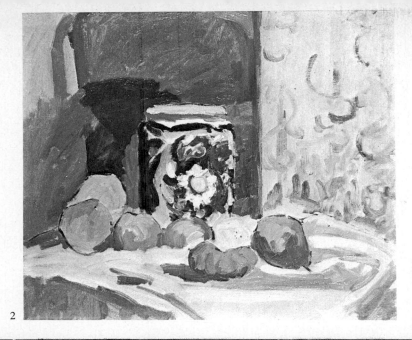
2

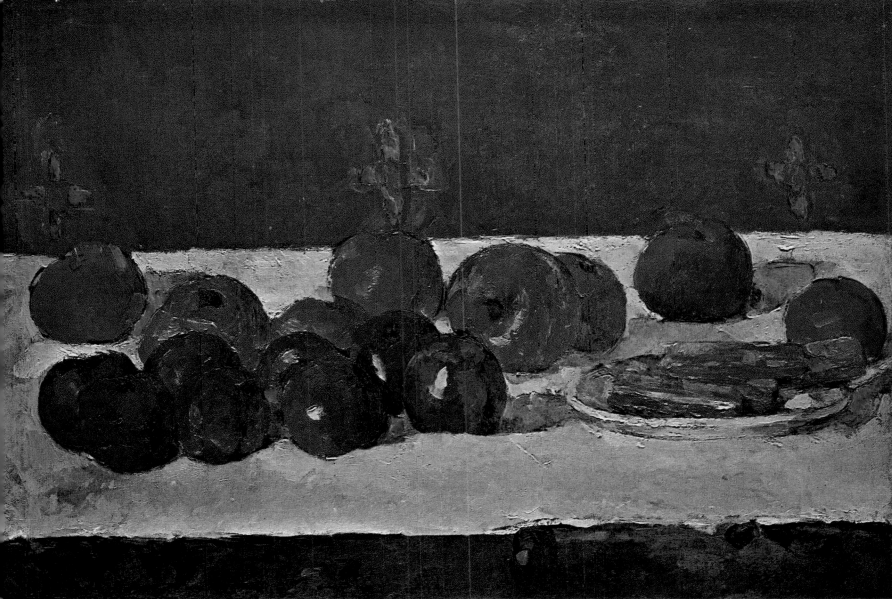
3

solitude that suited his temperament. "Isolation is what I deserve," he said; and the word "deserve" is more significant than he perhaps realized. "To deserve isolation" did not mean to be safe from those who, on one pretext or another, might want to "get their hooks into him." It must be understood to mean what Leonardo da Vinci meant by his imperious advice to artists: "If you are alone, you belong only to yourself." "To deserve isolation"—that noble and

simple expression further implies that society can have no hold over the creative artist, who is fully himself only in solitude. Cézanne ceased to exhibit because he was indifferent to fame. "Man is made to remain obscure," he said twenty years later to Joachim Gasquet. The stir and fuss made in connection with the Impressionists and the controversial publicity they were given, simply strengthened his conviction that it was better to keep to himself.

Returning to his native Provence, whose austere beauties exactly suited his own temperament, he now proceeded to take the second major step in his career. Without rejecting anything of what he had learned from the Impressionists, he went beyond their shimmering surface effects and gave forms a new architectural solidity. Thus began his "constructive" period, already heralded in the non-Impressionist structuralism of some of his Pontoise and Auvers pictures.

The constructive period

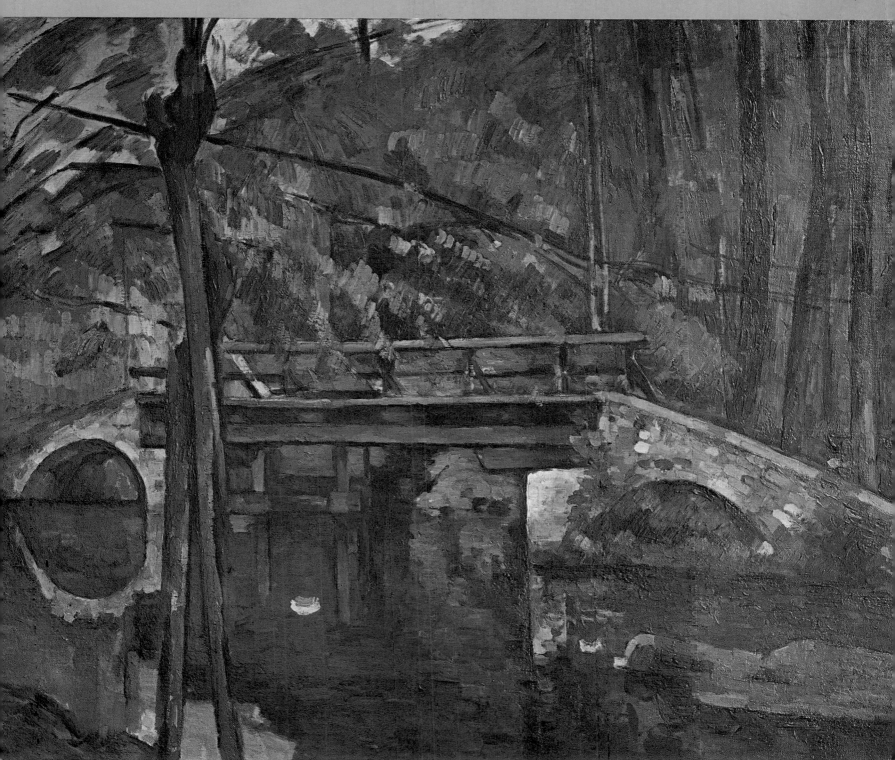

The Bridge of Maincy, 1882–1885.
Canvas, $23^{1}/_{4} \times 28^{3}/_{8}$ in. Paris, Musée du Louvre.

1 Study of a tree, 1886–1890. Pencil, sheet
8 × 4⁷/₈ in. Sketchbook III, p. 19.
(Chappuis no. 171). Basel,
Kupferstichkabinett.

2 Zola's House at Médan, 1879–1881.
Canvas, 23¹/₄ × 28¹/₂ in.
Glasgow, Art Gallery and Museum, The
Burrell Collection. 1

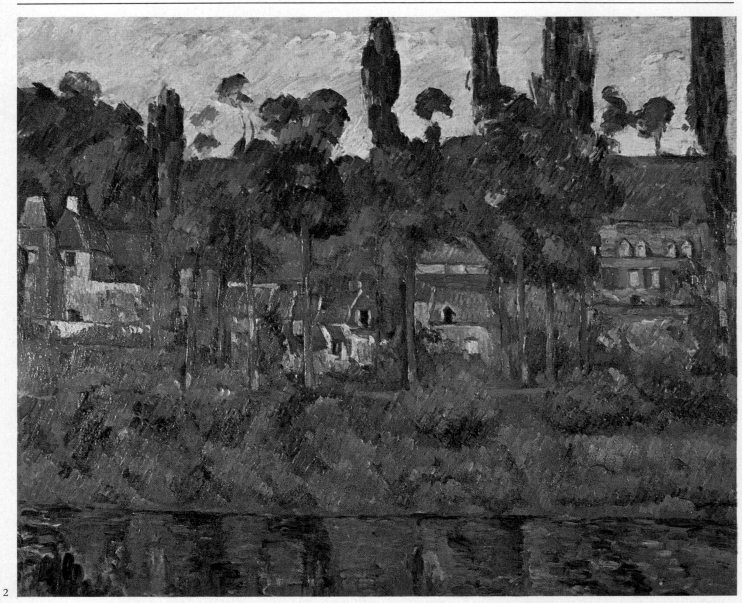

2

The key, or one of the keys, to his work of this period is supposed to be found in a famous statement of Cézanne's, often quoted and often misunderstood: "Treat nature according to the sphere, the cylinder, and the cone."[17] From that, it would be all too easy to assume that he gave direct rise to Cubism; in reality, the aims and methods of the Cubists were quite different from those of Cézanne in his constructive period. He began now to work his way toward a natural synthesis that had nothing

systematic about it, nothing theoretical or intellectual; it proceeded above all from his eye and his painterly instincts. In contrast to the analytical vision of the Impressionists, Cézanne developed a synthetic vision based on the underlying geometric structure of forms. Sense impressions provided the basis on which the mind worked. To compare one of the most representative canvases of this period, *Rocks at L'Estaque* (Museu de Arte, São Paulo), with a Horta de Ebro landscape by Picasso or L'Estaque land-

scape by Braque (as they are compared in Liliane Guerry's book)[18] is to see clearly what separates them and what unites them. Cézanne, moreover, progressed from one period to the next through a series of imperceptible transitions. There was no rift or break; his was an organic development, in keeping with nature, which, as the Latin proverb says, "makes no leap." Even in points of detail his evolution is difficult to trace, for already in his Impressionist years he was intent on a structural order,

38

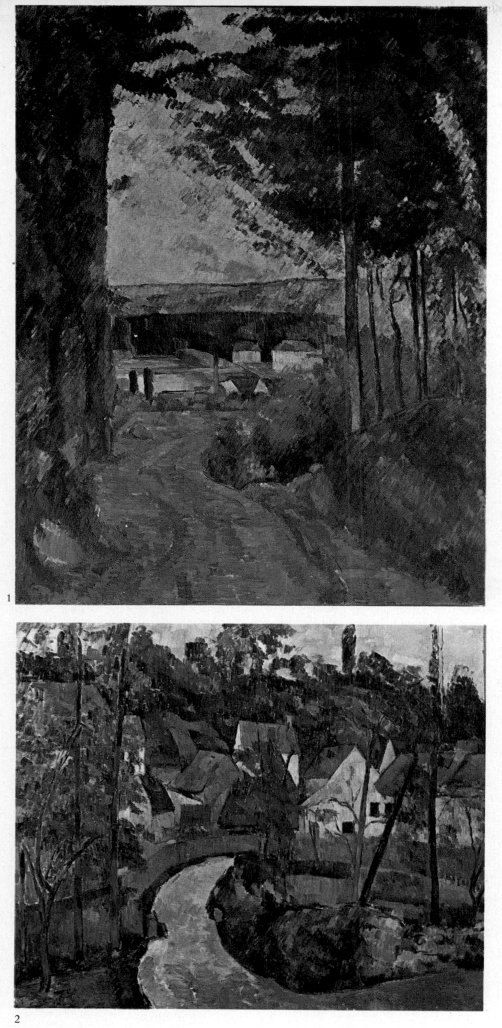

3

1 **Street Leading to a Lake, 1879–1882.**
 Canvas, 31⁷/₈ × 23⁵/₈ in.
 Otterlo, Kröller-Müller Stichting.

2 **The Turn in the Road, 1879–1882.**
 Canvas, 23¹/₂ × 28¹/₂ in. Boston,
 Courtesy of The Museum of Fine Arts,
 John T. Spaulding Bequest.

3 **In the Garden, c. 1880. Pencil, sheet**
 5⁵/₈ × 7³/₄ in. (Chappuis no. 102).
 Basel, Kupferstichkabinett.

and what he had learned at Pontoise and Auvers continued to govern his palette and brush. Certain existing tendencies gained momentum as others were overlaid or discarded, and these carried him in a definite direction, one which he consciously and tenaciously pursued. This was a period of growing abstraction. As eye and mind advanced in unison, his forms were gradually reduced to a stark purity and simplicity, a near abstraction that set the course of his work for well over fifteen years, roughly from 1878 to 1895.

His mastery of landscape was developed and extended in the treatment of two subjects to which he returned again and again: the port of L'Estaque, which provided some of his favorite motifs, particularly the view of the town from the heights of the Nerthe massif, which he painted nineteen times over fifteen years; and the staggered tiers of houses in the old hilltop village Gardanne, near Aix, whose architecture takes on a distinct Cubist look in his canvases, for example, the *View of Gardanne* (Barnes Foundation, Merion, Pa.), almost hallucinatory, in its two-dimensional patterning.

But these were not his only themes. He also worked outdoors at Jas de Bouffan, a fine countryhouse just outside Aix that

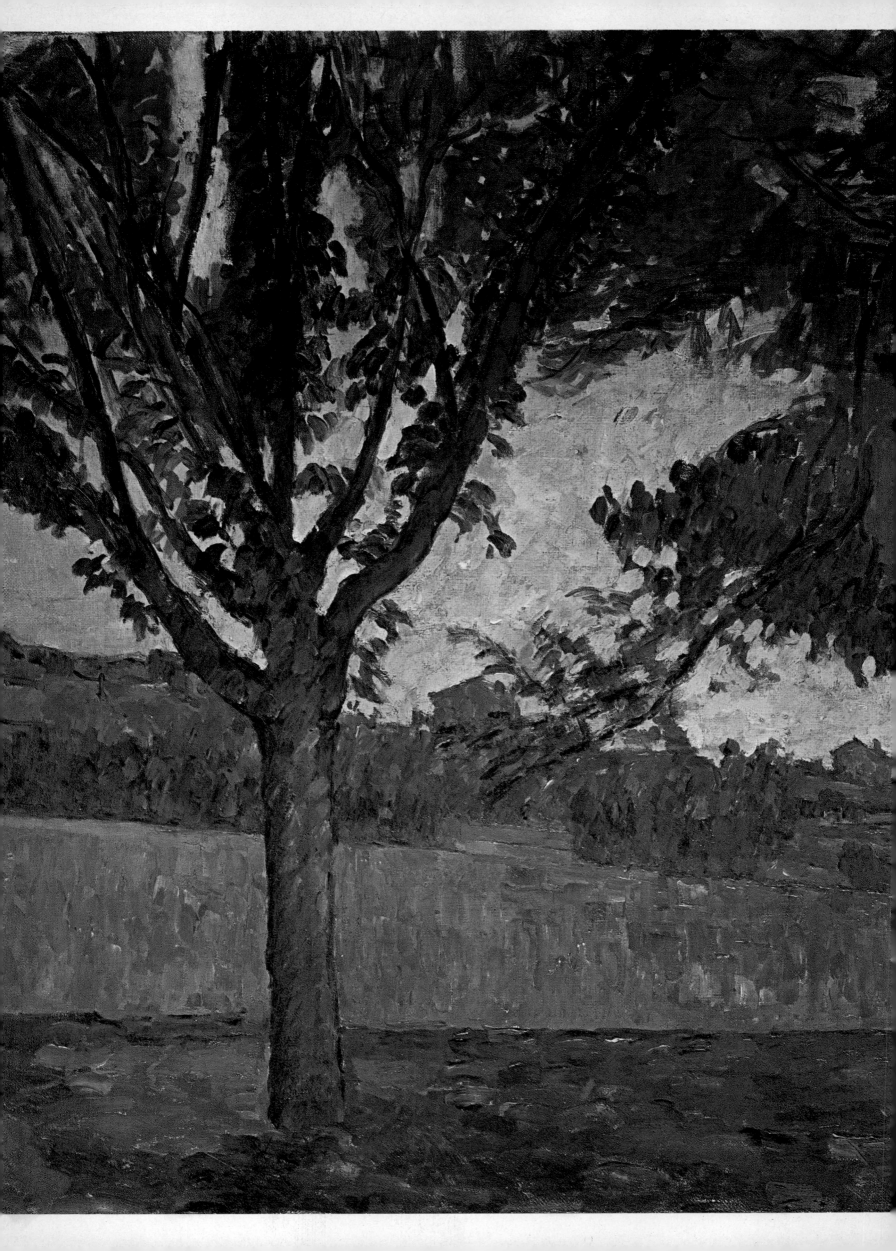

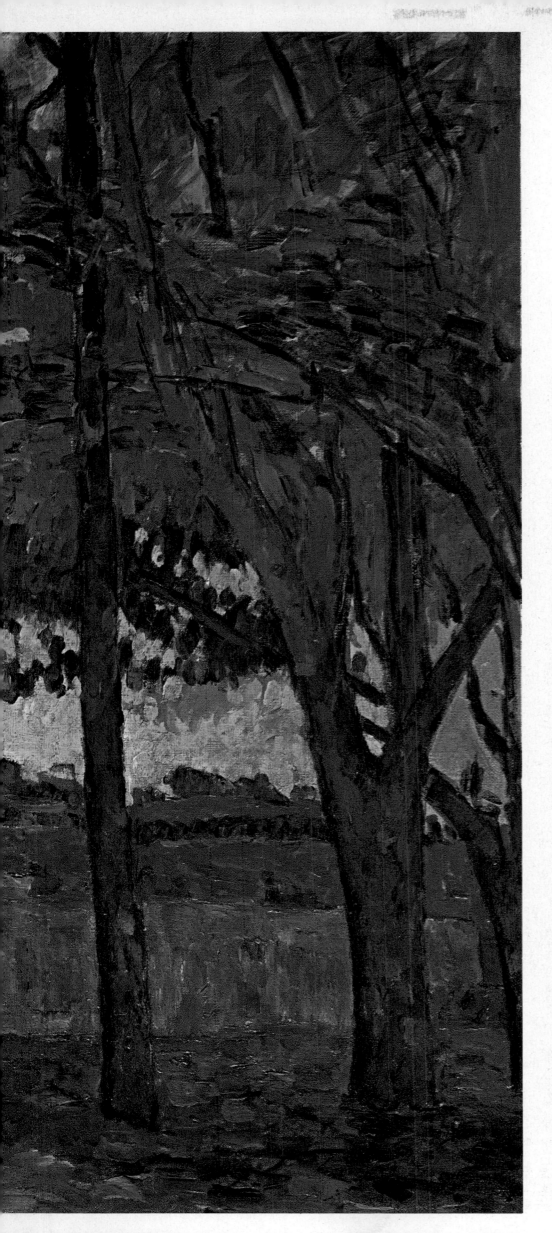

At the Jas de Bouffan, 1882-1885.
Canvas, 23^5/$_8$ × 28^3/$_4$ in.
U.S.A., Private collection.

his father had bought in 1859. At this
period of his vigorous maturity, when
all that was deepest and unique in his
genius was coming out in his marshal-
ing of forms and colors, the canvases
he did there take on a rare magnificen-
ce. The trees he painted, often remi-
niscent of the poplars at Auvers, became
monumental as he responded to an im-
perious need to rebuild the landscape,
imposing on reality an architectural
order verging on abstraction and
transmuting the vegetable growth of
nature into almost geological forms.
Thus in his *Jas de Bouffan* (Narodni
Gallery, Prague) the vegetation is reduc-
ed to a few indefinable synthetic masses.
In *Chestnut Trees at Jas de Bouffan* (Min-
neapolis Institute of Art) the sober
pyramid of Mont Sainte-Victoire is
viewed through the taut network of
bare trees in the foreground.
This brings to mind the simplified pat-
terns of the Primitives, who treated
landscape like an idealized allusion to
nature, and Lionello Venturi was right
in saying that "by a complex, deliberate
effort Cézanne rediscovered the naïveté
of vision." Even this depends on the
sense we give to the word "naïveté,"
which does not mean a wholly spon-
taneous rendering of nature but, on the
contrary, a return to primal simplicity,
which very often can only be reached
by a roundabout way—in Cézanne's
case, a roundabout way that led him
through the Impressionist camp and
back out again.
"He was not born a primitive, he
became one," as Venturi rightly says.[19]
Undoubtedly it required the experi-
ments of his early romantic period and
the coaching of Pissarro to rid him of
many artifices and help him reach that
point where mind and senses work
together with the maximum effec-
tiveness. According to Guerry, it was a
conscious, deliberate simplification of
vision. She compares Cézanne's L'Esta-
que pictures with those of genuine pri-

41

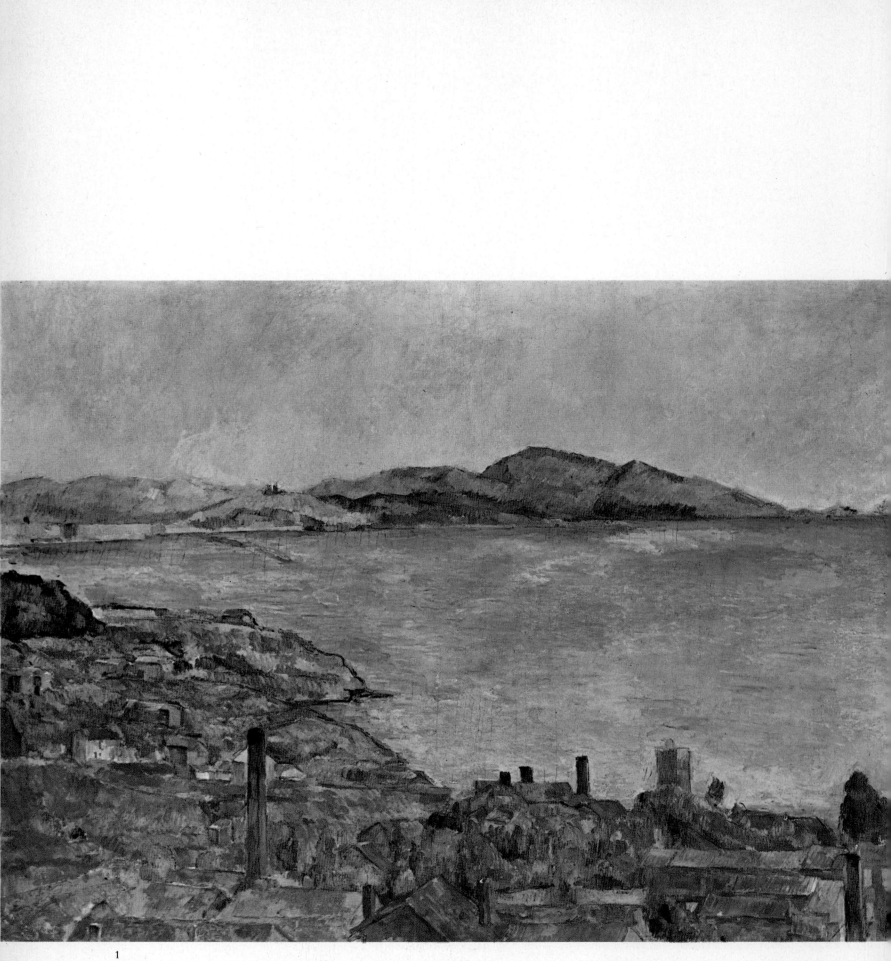

1

mitives: the New York version, for example, with Lorenzetti's small seascape in Siena. She points out that the fundamental difference between the early primitivism of the Italian master and Cézanne's late primitivism lies in the fact that with Cézanne "the illusion of perspective is obtained by treating reality... as a single plastic mass. It is because the whole landscape holds together like a single volume that the sweep of this volume suggests the existence of a third dimension."[20]

Rocks at L'Estaque (Museu de Arte, São Paulo) is a telling example of this cohesive unity which Cézanne imposes on landscape. These crags are like the result of a volcanic upheaval. The rocky aridity of the Provençal hills in the region of the Nerthe massif is emphasized with grandiose harshness. When Cézanne said that he could not paint a landscape until he knew its exact geological nature, he did not mean a

1 **The Gulf of Marseilles at L'Estaque,**
1883-1885.
Canvas, 28³/4 × 39³/8 in.
New York, The Metropolitan Museum
of Art, Bequest of Mrs. H.O.
Havemeyer, 1929.

2 **L'Estaque (Gulf of Marseilles),**
1883-1885. Canvas, 22⁷/8 × 28³/8 in.
Paris, Musée du Louvre.

scientific knowledge but rather that insight which comes of intuitive experimentation and close communion, daily renewed, between man and the earth. In other words, Cézanne could not paint a landscape he had not felt and experienced, and his experience of it was formulated with a concentrated perception in which all his senses seemed to take part. Then, building on the evidence of the senses, the mind gives final shape to a visionary composition in which the rocks seem to heave and swell, leaving only a small part of the canvas for a thin strip of sea and a patch

plained to Gasquet, with his usual honesty and bluntness: "You may say what you like, but to play at ignorance and naïveté is the worst kind of decadence. Senility. Today one cannot help knowing, learning all by himself. His craft is something he has imbibed from the time he was born." Of course there are contradictions in the recorded statements of Cézanne; but these merely testify to his evident sincerity and also show that he was sometimes mistaken about himself. The truth is that it cost him exhausting, unremitting effort to master his "craft"; it was not something

vious premises. And so, throughout this period, beginning with the revelations of open-air painting at Pontoise and Auvers, he doggedly pursued something that eluded him, something that he grasped, lost, and then grasped again, as we see so vividly in the pictures of "Bathers" which became a leitmotif and touchstone of his art during the last thirty years of his life. A whole book could well be devoted to an analysis of these many paintings of "Bathers." Despite the apparent uniformity of subject matter, they show an endless variety of treatment, even though the natural setting is always the same: the banks of the Arc, a stream which flows by Aix and which can be jumped over in three bounds. With the play of sunlight among the leaves and its reflections glinting on the water, these pictures seem to show a revival of interest in Impressionism; and that is true to some extent. But the nude figures, male or female, under the majestic arch of trees are treated monumentally, and what might have lapsed into pure Impressionism, in the hands of another painter with no reservations about dissolving forms and colors in light, becomes with Cézanne a solid and powerful construction.

Three magnificent and convincing examples come to mind: the versions of the *Large Bathers* in the Philadelphia Museum of Art, the National Gallery in London, and the Barnes Foundation in Merion, Pennsylvania. The reality that provided the starting point for vision or imagination was steadily broken up and recast as the picture progressed. Every natural element was distorted, subtly or daringly, to make it conform to the artist's requirements of pictorial design, to an abstract recreation of nature. One is reminded of Romanesque portal sculptures, in which certain figures are contorted, elongated, or even amputated in order to fit into the available space. "The object was the starting point for speculative patterns of design. Soon the

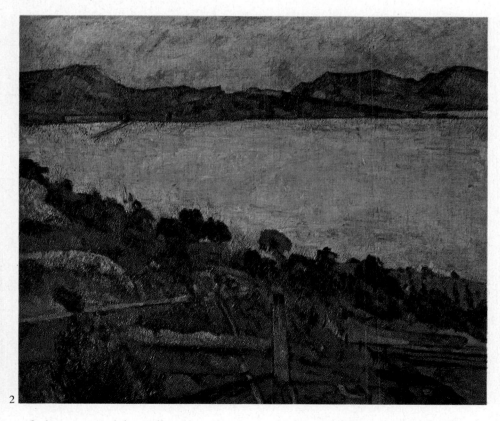

2

of sky occupied by sallow, compact clouds.

Cézanne's simplicity, resembling that of a "primitive" (but this word must be used with great caution), was never a systematic formula. He himself considered that simplicity as one possible outcome of the technical experiments and attainments of a lifetime. As he ex-

which came to him or which he absorbed "from the time he was born." One of his last remarks was that each day he was still making "slow progress." Each picture was a conquest, a forward stride in exploring an unknown country, a new visual experience, an enlargement of the mind, an extension of technical mastery, a tireless verification of pre-

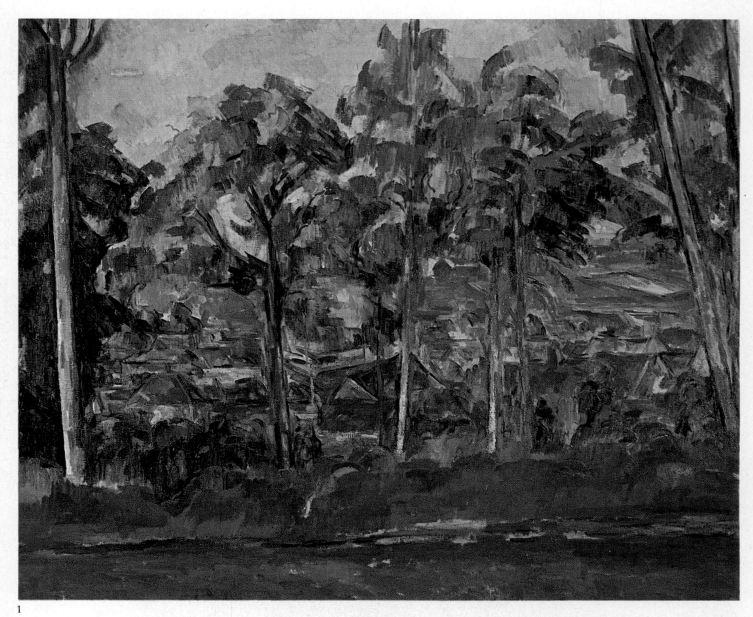

1

painter transcended the visual data and bent them to an abstract order of construction" (Guerry). In other words, Cézanne began with a natural object which served as the basis for structural variants along abstract or near-abstract lines. Later, when his whole art came to be dominated by the pure glow of light, these structures were to take on the unreality of a mirage, as if floating in heat haze or swept by the wind. But now his pictorial architecture stood on firm foudations, even though the solidi-

ty of its components remained ambiguous.

Looking at these "Bathers," one is tempted to say, with Shakespeare, "We are such stuff as dreams are made of." For all their sturdy vigor, these figures are filled with the tremulous ambivalence of a dream. There is something spectral about them, just as there is about the portraits of this time: *Madame Cézanne with Loose Hair* (Philadelphia Museum of Art), *Self-Portrait on a Blue Ground* (Pellerin Collection); and above all

Madame Cézanne in a Yellow Chair (Pellerin Collection); also the extraordinary *Mardi Gras* (Pushkin Museum, Moscow) and the series of *Harlequins* (various private collections) that goes with it, and a good many drawings, too. These portraits may be spectral as far as the sitter's appearance goes; but while the individuality of the human figure is ignored, that figure acquires a rocklike density as shape and design. In pictures such as *Madame Cézanne in a Yellow Chair* and *Mardi Gras*, the figures are as

1 Village Seen Through Trees, c. 1885.
 Canvas, $25^5/8 \times 31^7/8$ in.
 Bremen, Kunsthalle.

2 Glass and Pears, 1879-1882.
 Canvas, $7^1/8 \times 15$ in.
 U.S.A., Private collection.

3 Table Set for a Meal, 1875-1876?
 Canvas, $10^7/8 \times 20^1/8$ in. U.S.A., Private
 collection.

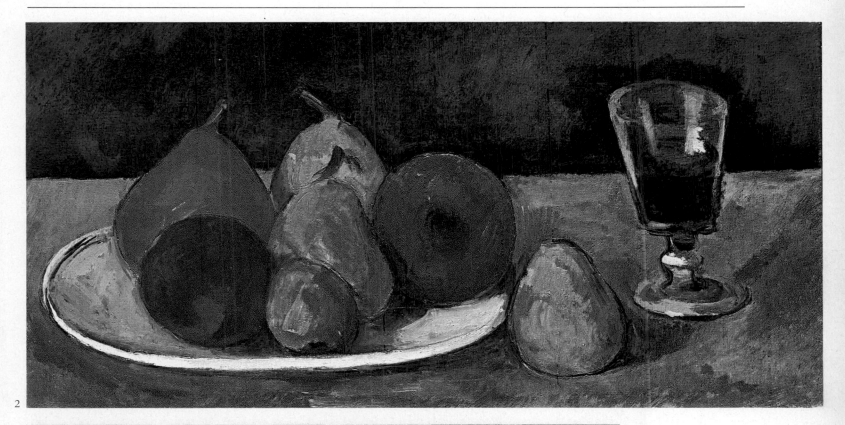

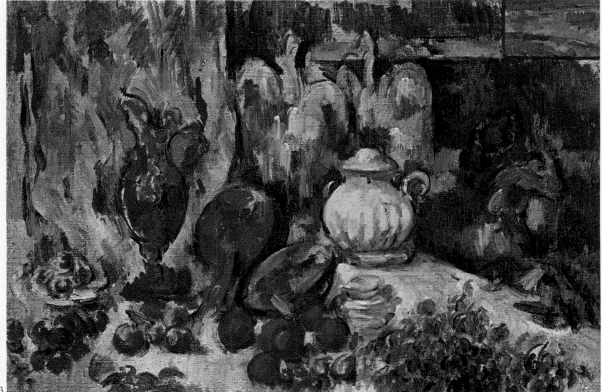

firm and dense as a piece of sculpture. Not that the illusion of three dimensions is perfectly convincing; space with Cézanne is always a continuum apart, unlike any other. One is struck by the sculptural modeling of these faces and others, such as *Woman with a Coffee Pot* of 1890—1894 or *The Card Players* (both Louvre), which stand on the borderline between this period and the next, as does also the *Portrait of Gustave Geffroy* (Lecomte Collection). This sculptural density speaks for Cézanne's guiding purpose and ambition: to give enduring shape to the perishable, by methods comparable to those of Poussin, the master whom, along with Delacroix, he most admired.

Cézanne's son and one of his young friends posed for the figures of Pierrot and Harlequin in *Mardi Gras*. Their fancy costumes and light, skipping step give them an air of unreality, of supernatural or simply whimsical apparitions, which obviously appealed to the painter. The color contrasts and the stability of the forms, beneath their apparent elusiveness, provide a striking example of the way in which the artist creates a new, triumphantly objective reality, or super-reality—that of pure pictorial design, on the basis of actual figures impersonating the fanciful characters to be found in Italian comedy. Because Cézanne created his own space and broke away from traditional perspective and because he chose to paint his pictures, especially his still lifes, from arbitrary points of view and unusual angles of vision, the relations of masses are reorganized and rebalanced in a manner that puzzled his contemporaries, for it disregarded all conventional notions either of reality or of art. To that new structural design, all post-Cézanne painting, from the Expressionists and Fauves to the Cubists, was heavily indebted. Among the major examples that come to mind are *Still Life with a Straw-Plaited Vase* (Louvre), *Straw-Plaited Vase*

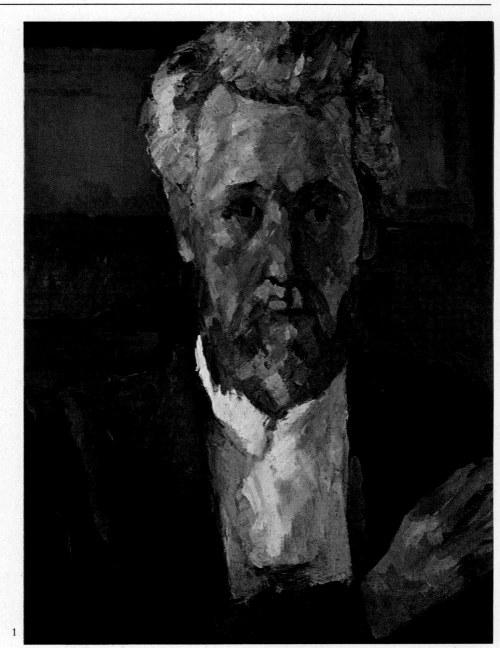

1

1 Portrait of Victor Chocquet, 1879-1882. Canvas, 13³/₄ × 10⁵/₈ in. U.S.A., Private collection.

2 Studies of furniture and head of the artist's son, 1882-1884. Pencil, sheet 12³/₈ × 18⁵/₈ in. (Chappuis no. 101). Basel, Kupferstichkabinett.

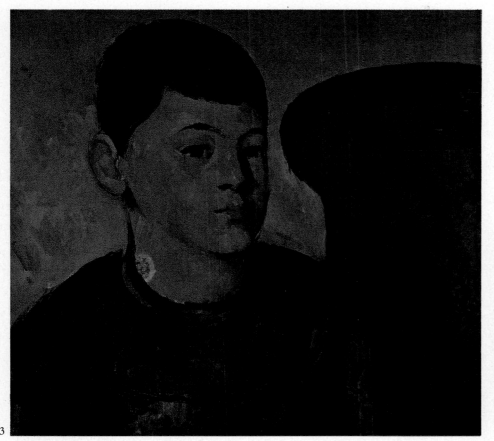

3

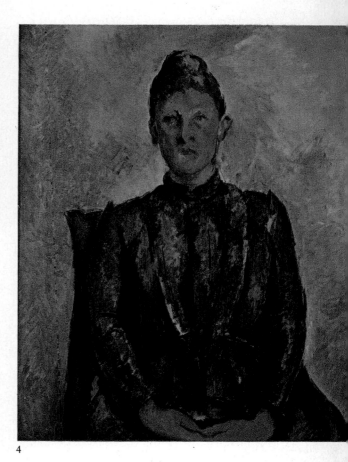

4

3 Portrait of the Artist's Son Paul,
1883–1885. Canvas, $13^3/4 \times 15$ in.
Paris, Musée du Louvre.

4 Portrait of Madame Cézanne in a
Pleated Dress, 1885–1890. Canvas,
$31^7/8 \times 25^5/8$ in.
Paris, Musée du Louvre, Orangerie.

(Guillaume-Walter Collection), *Apples with a Jug* (Pushkin Museum, Moscow), and the amazing *Still Life with a Yellow Cushion* (Louvre), which, as someone has said, "looks as if it might collapse like a house of cards." Intent on his own idea of reality, his own spatial construction, Cézanne disregarded the laws of nature and the rules of perspective. What he saw, he recreated in terms of what he felt and imagined, adding a new, perhaps abstract but basically objective, dimension to the thing he had seen.

He was adept at choosing and combining angles of sight that focus the eye on structures of a landscape, at disposing fruit, bottles, and tureens on a table or figures in an easy-chair or standing, all in such a way that the subject became a new, self-contained reality. The resul-

ting pictorial harmony was one of the finest achievements of his constructive period, in which reality was deepened and enriched by abstraction. From the marriage of these two apparently contradictory powers—the perception of nature and the spirit of abstraction— Cézanne gained the basis for his overthrow of the pictorial traditions which, until then, still shackled even those who rebelled against them. To subordinate the subject matter to the organizing intelligence and the demands of pictorial design—such was the outcome of his disciplined and unrelenting efforts, which at the same time saved him from the pitfalls of a solely intellectual or a naturalistic approach, after the manner of Zola's writing or of Courbet, an artist for whom he continued to have great admiration.

The great synthesis

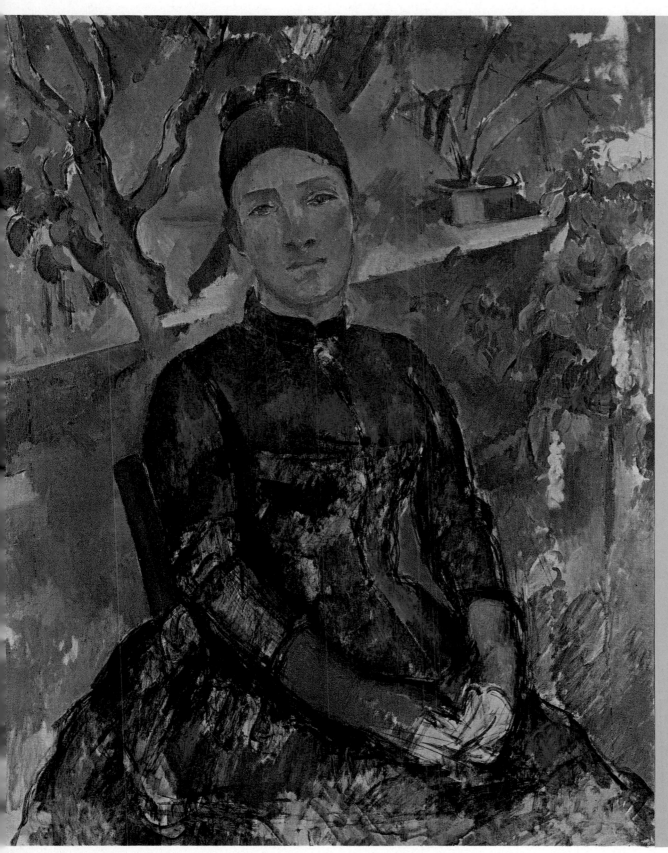

Madame Cézanne in the
Conservatory, c. 1890.
Canvas, 36¹/₄ × 28³/₄ in.
New York,
The Metropolitan Museum of Art,
Bequest of Stephen C. Clark, 1960.

Only a decade remained for Cézanne to complete his life's work. As if he had a presentiment that time was getting short, he worked on with mounting eagerness and intensity. This final period, beginning in the key year 1895, was more fruitful than any other. He painted more than three hundred pic-

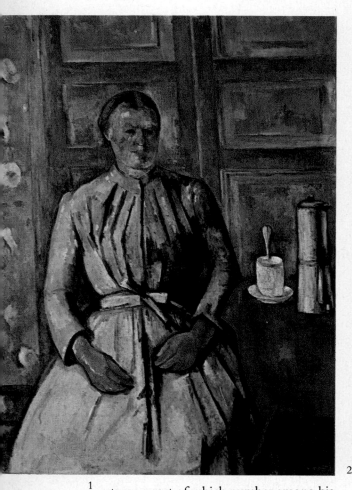

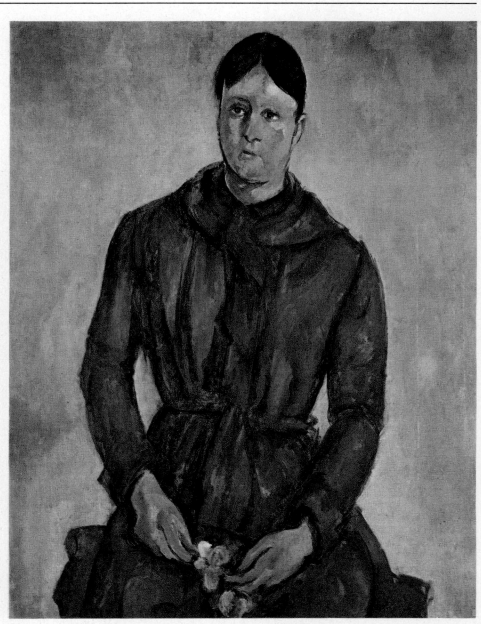

tures, most of which number among his masterpieces. These included twenty-one compositions of male or female bathers, seven self-portraits, eighteen portraits of his wife, three portraits of his son, four versions of *Young Man in a Red Waistcoat*, five versions of *The Card Players*, and fifty-four still lifes; the rest were landscapes.

There were few days that did not find him at his easel, either indoors or outside. A month before his death, on

1 Woman with a Coffee Pot, 1890–1894? Canvas, $51^{1}/4 \times 38^{1}/4$ in.
Paris, Musée du Louvre, Lecomte-Pellerin Collection.

2 Portrait of Madame Cézanne in Red, 1890–1894. Canvas, $35 \times 27^{1}/2$ in.
São Paulo, Museu de Arte.

3 The Reader, 1894–1896. Canvas, $31^{7}/8 \times 25^{5}/8$ in.
U.S.A., Private collection.

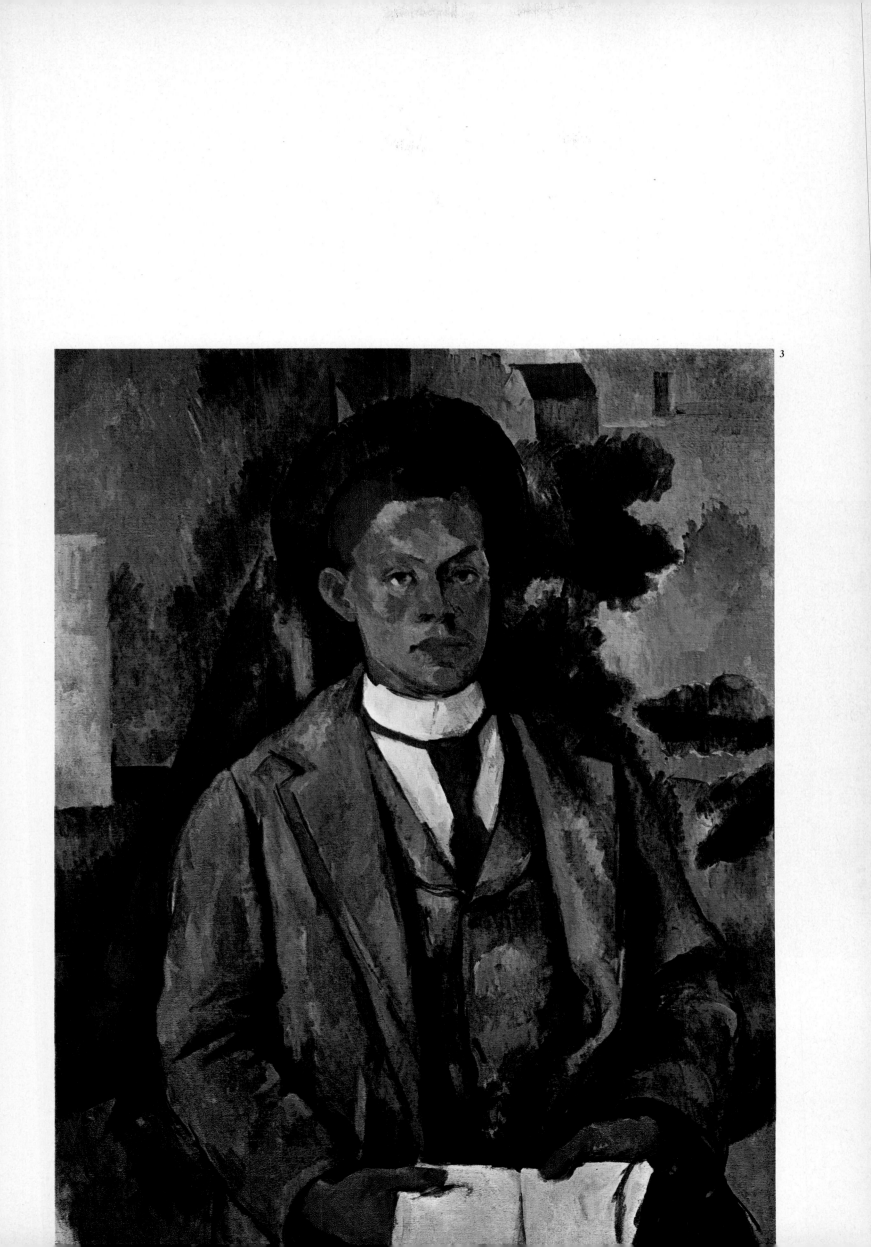

3

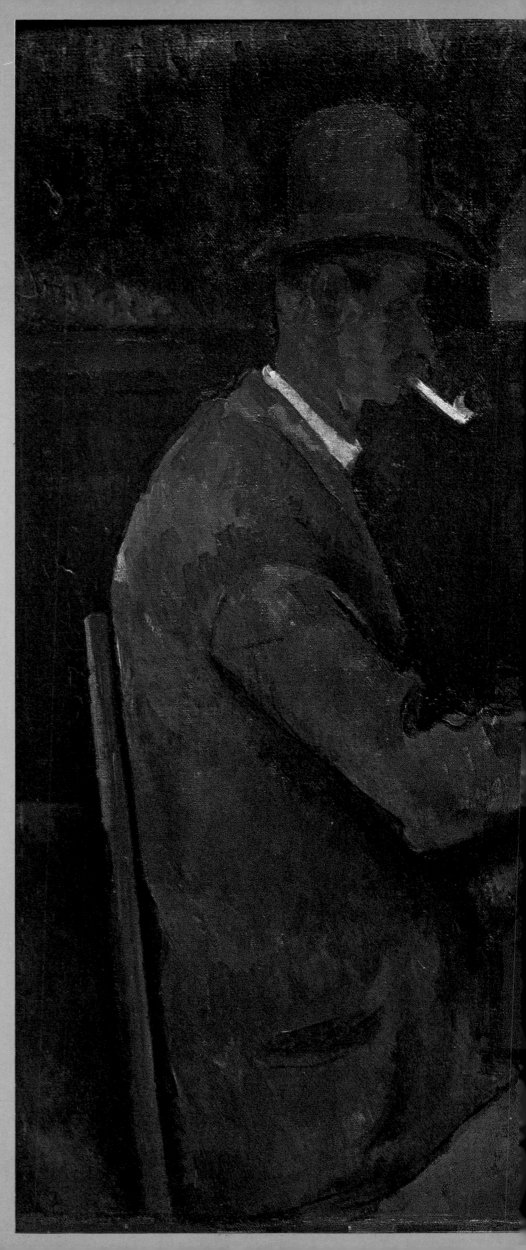

The Card Players, 1890-1892.
Canvas, $17^{3}/_{4} \times 22^{1}/_{2}$ in.
Paris, Musée du Louvre.

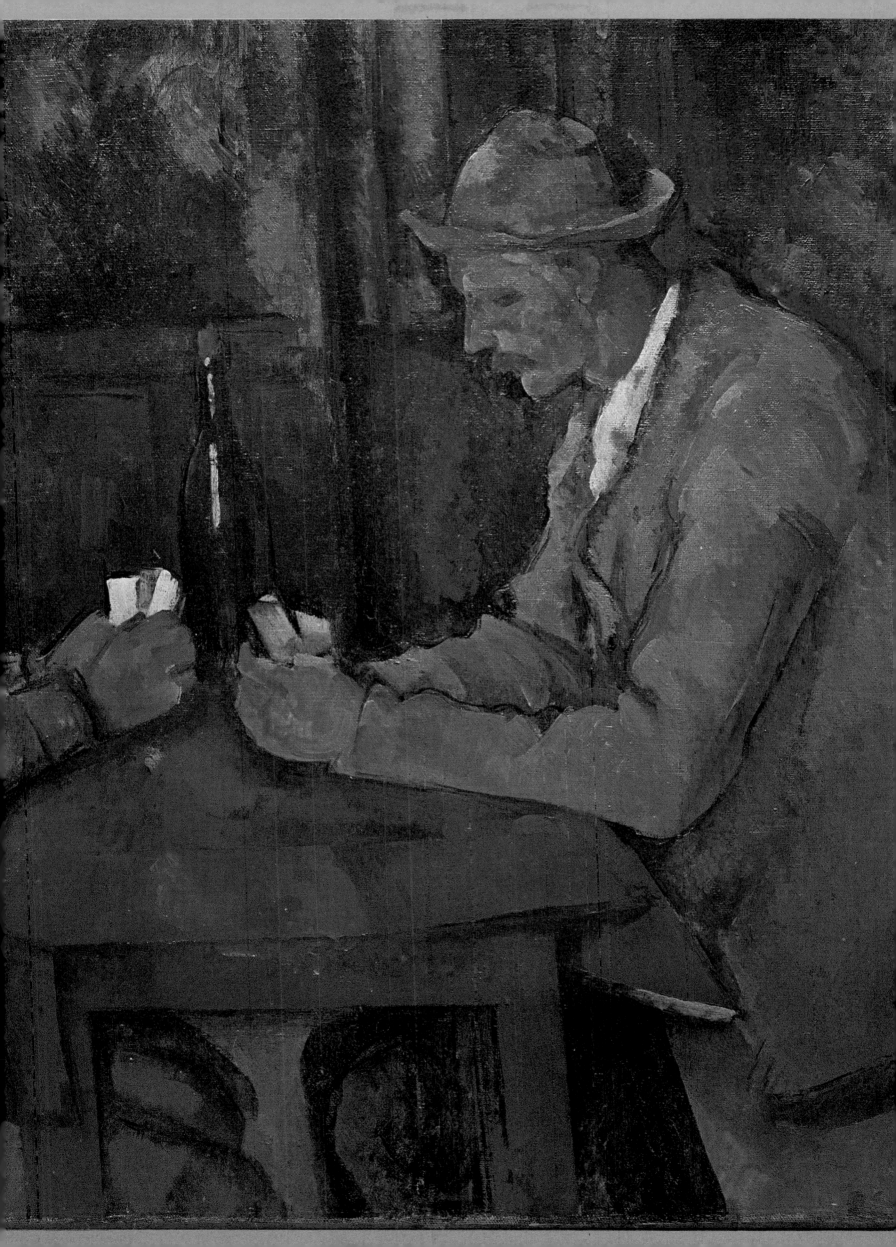

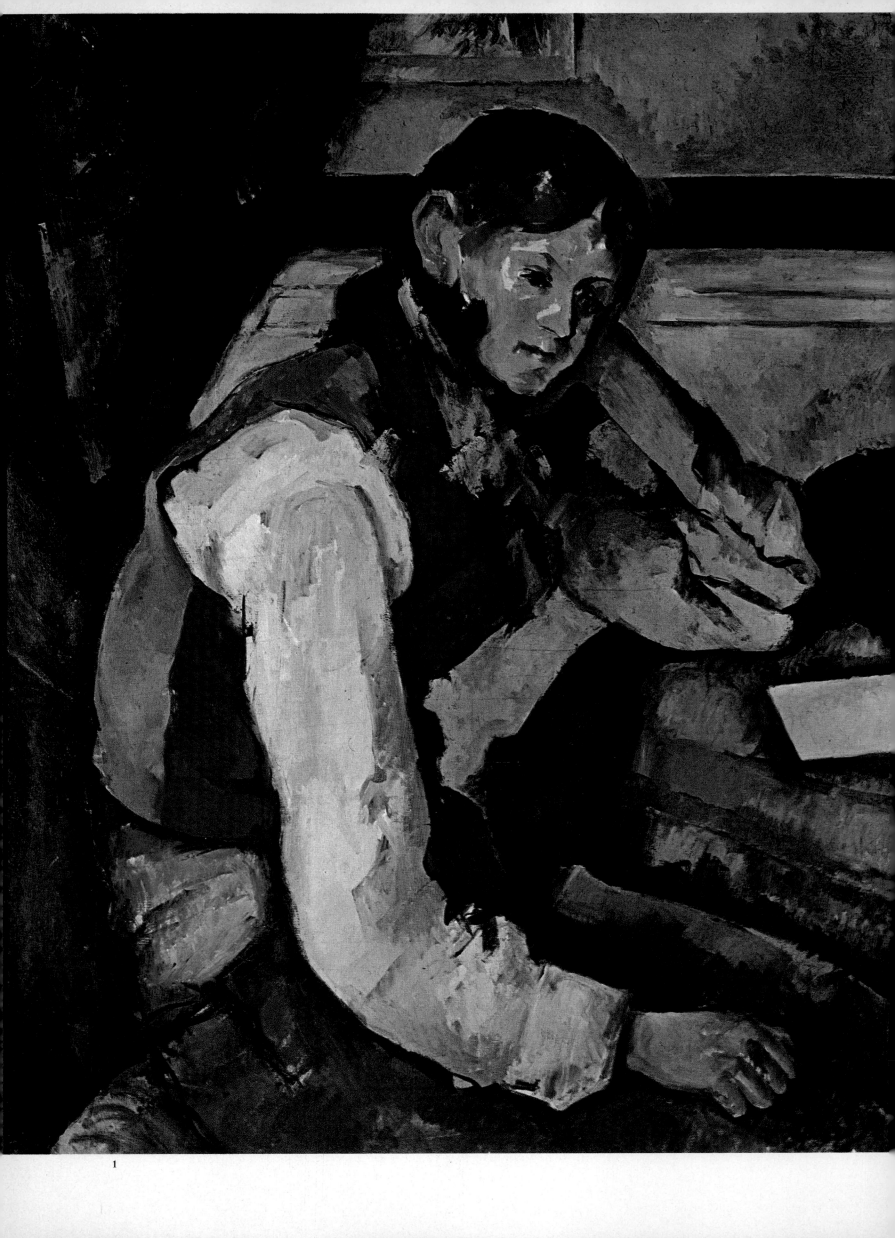

1

September 21, 1906, he wrote to Émile Bernard: "I am still working from nature, and it seems to me that I am slowly progressing. I would have liked you to be here with me, for one always feels the weight of solitude. But I am old and ill, and I have sworn to die painting."

There are signs of an obsession with death in the recurring still lifes with a skull, unexpectedly strange and disturbing, which appear in this period. The skull is now treated as a *memento mori*.

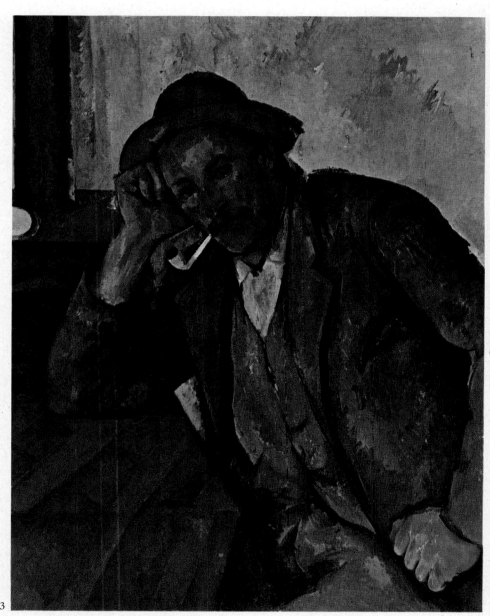

In his youthful *Penitent Magdalen* it had only been a traditional accessory taken over, almost as a stylistic exercise, from the old masters. In 1896, it abruptly reappeared in *Portrait of a Young Man* (Barnes Foundation, Merion, Pa.), a Hamlet-like meditation which may be a reminiscence of Delacroix, but which more likely answers to a deeper, more personal preoccupation. This would account for the fact that Cézanne was particularly fond of the work and spoke of

1 Boy in a Red Waistcoat, 1890-1895. Canvas, 31¹/₄ × 25¹/₄ in.
 Zurich, Bührle Collection. (Photo Studio Arborio Mella, Milan)

2 Study of a head, 1876-1880. Pencil, sheet 9¹/₄ × 5⁷/₈ in.
 (Chappuis no. 91).
 Basel, Kupferstichkabinett.

3 Man with a Pipe Leaning on a Table, 1895-1900. Canvas, 36¹/₄ × 28³/₄ in.
 Mannheim, Kunsthalle.

1

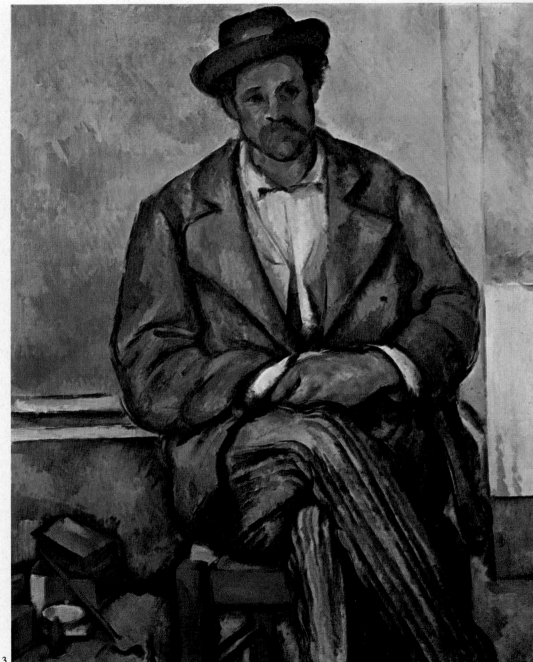

2 3

it several times to Gasquet, clearly not only because of its structural and pictorial beauty.

After the uncontrolled outpourings of his early romantic-expressionist period, Cézanne seemed to have thrown off or outgrown those moods of melancholy which had impelled him to paint violent

scenes of crime and death, in which even sensuality took on funereal accents. For years any allusion to the tragic aspect of life had disappeared from his canvases, aside from that tragic pathos, that brooding of the elements, which underlies all nature and makes itself felt in his landscapes. The skull over which this

young Provençal Hamlet (with whom Cézanne perhaps identified) was shown brooding reappeared, strangely enough, among fruit in his late *Still Life* in the Barnes Foundation, datable to the first half of his last period, between 1895 and 1900. Skulls continued to appear in his later pictures, but detached from living

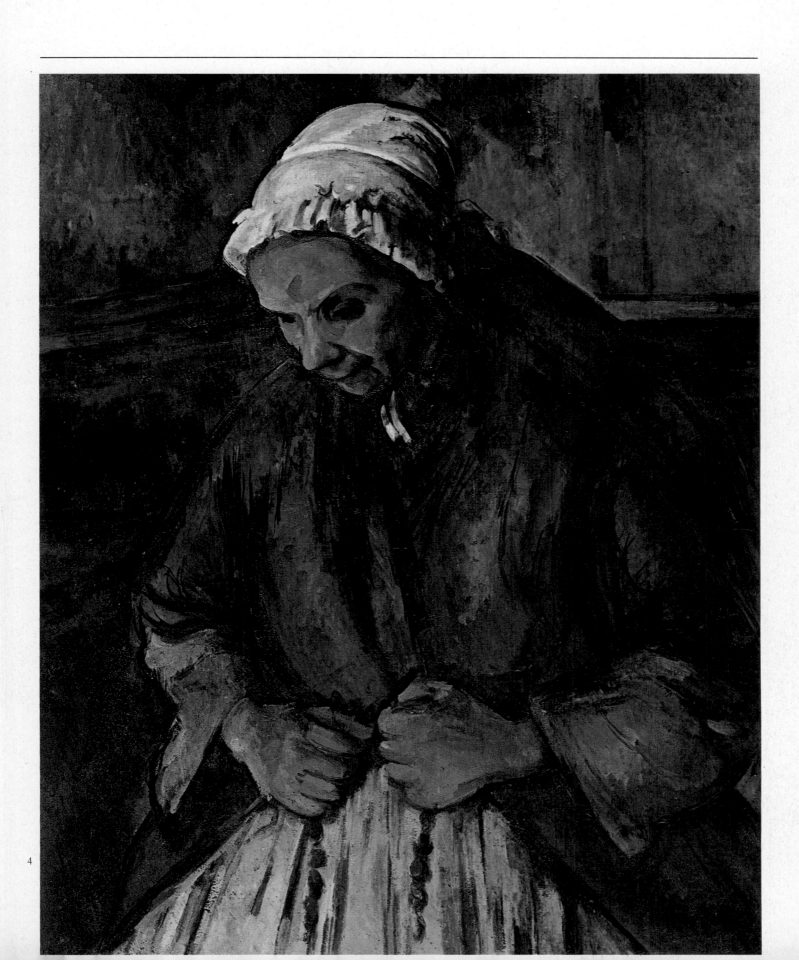

4

2

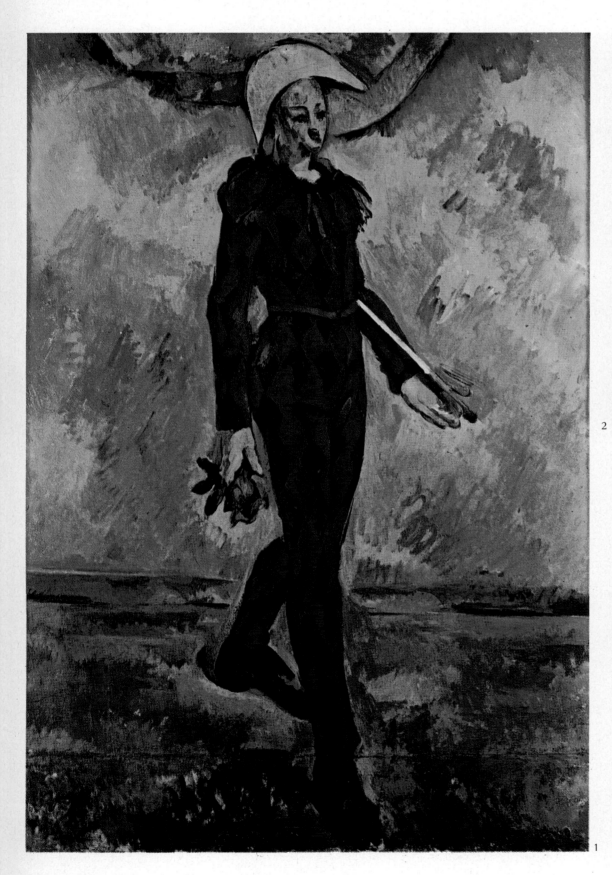

things: three are grouped on an Oriental carpet; one stands alone in a still life; in another, three more are found; in still another, they form an arresting pyramid.

This series is too exceptional and covers too brief a time span (1900 to 1904) to denote a genuine obsession; yet, from the unfaltering intensity with which he worked on, going out daily and painting to the point of exhaustion, it is clear he was haunted by a fear of leaving his task uncompleted. According to Émile Bernard, Cézanne was an early riser and, throughout his working life, was in the habit of painting in his studio from 6 to 10:30 A.M. He then had lunch and immediately afterward went out to work on a landscape motif until five o'clock. He came home, had dinner, and went straight to bed. Bernard adds: "I have sometimes seen him so exhausted by his work that he was unable to talk or even to listen."

Zola's death in 1902 affected him deep-

1

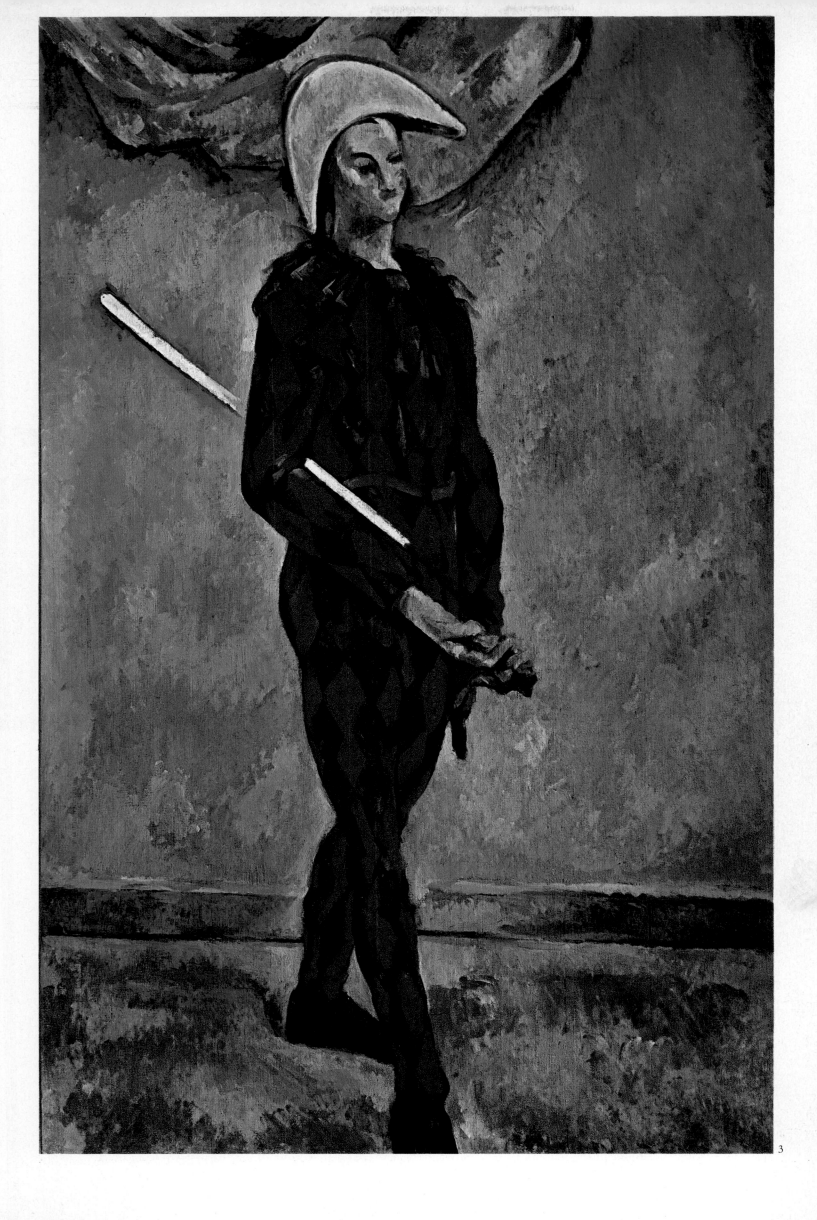

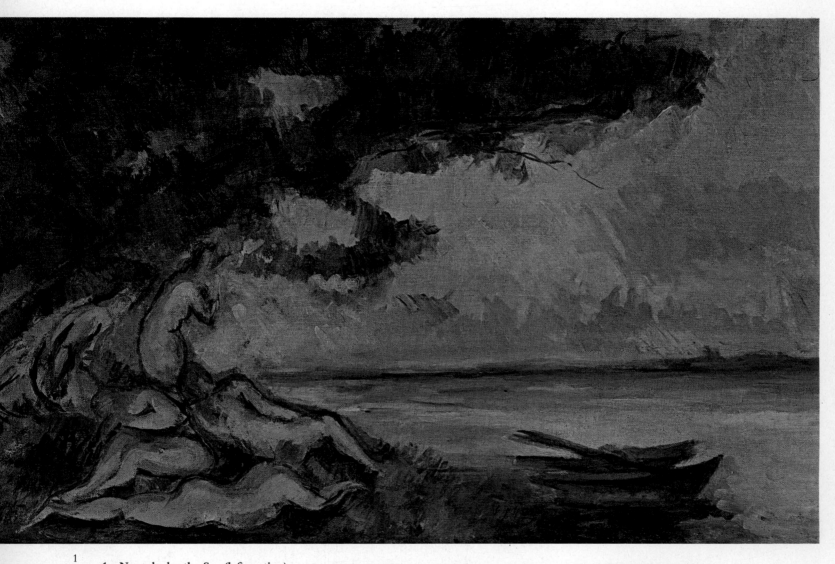

1

1 Nymphs by the Sea (left section),
 1890-1894.
 Canvas, $11 \times 18^{1}/_{8}$ in.
 Paris, Musée du Louvre, Orangerie.

2 Cézanne in Chemin des Lauves studio
 before version of "Large Bathers,"
 photograph.
 Paris, Sirot Collection.

3 Nymphs by the Sea (right section),
 1890-1894. Canvas, $11 \times 18^{1}/_{8}$ in.
 Paris, Musée du Louvre, Orangerie.

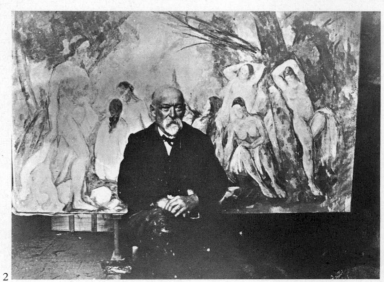

2

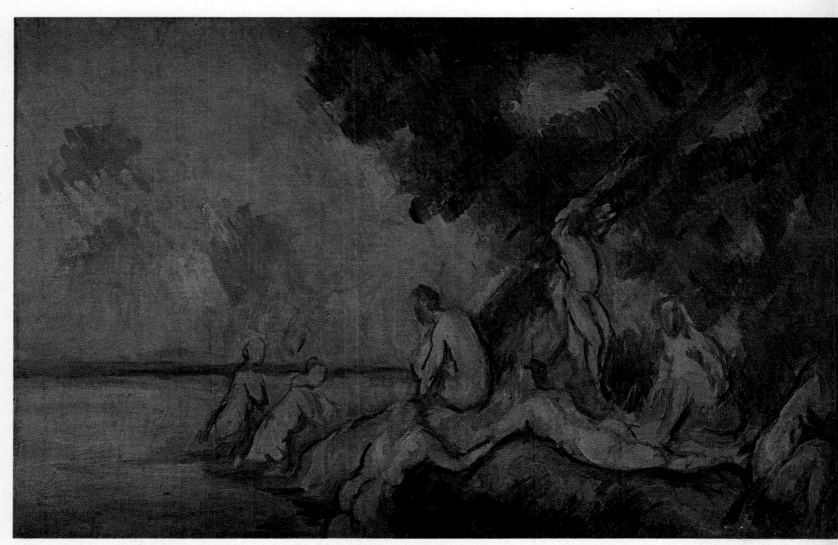

3

ly, even though all relations between them had ceased since the publication of *L'Oeuvre*[21] in 1886, disclosing the novelist's complete misjudgment of the genius and art of his boyhood friend. But, for Cézanne, a whole epoch of his life was associated with the strong-minded, ambitious Zola: their long rambles together in the countryside around Aix, dips in the cool waters of the Arc, endless discussions about art and poetry. They had many memories in common, besides the fact that both had some Italian blood in their veins.[22] When Zola died, Cézanne was sixty-three and was suffering from diabetes. Sensing that little time was left to him, he bent every effort to reach the goal he

had so long aimed at: to fathom and record nature's innermost secrets and to perfect the color technique he had worked out, which seemed to give the canvas the very pulse of life. As Renoir, who had learned so much from him, said: "Cézanne has only to lay in one dab of color; it is nothing, and it is beautiful."

When Cézanne left blank patches of un-painted canvas in certain pictures of this last period, it was not because he was unable to finish them or find the right tone. These apparent "blanks" are actually bridge passages across which the saturated colors beside them may free-ly vibrate. They are transitional areas where two colors which could not be

placed side by side face each other and optically blend. The vitality that emana-tes from these late canvases became even more intense as he lightened the "masonry" of pigments and painted more thinly, in delicately superimpos-ed touches of luminous, transparent color.[23]

In an effort to achieve greater luminosi-ty and transparency, he was led to devote more attention than ever before to watercolor painting. It was a medium he had always practiced, but chiefly as a means of testing forms and colors and for experimenting with composition. The watercolors done in the last decade of his life are not merely sketches; they are complete, self-contained works. For

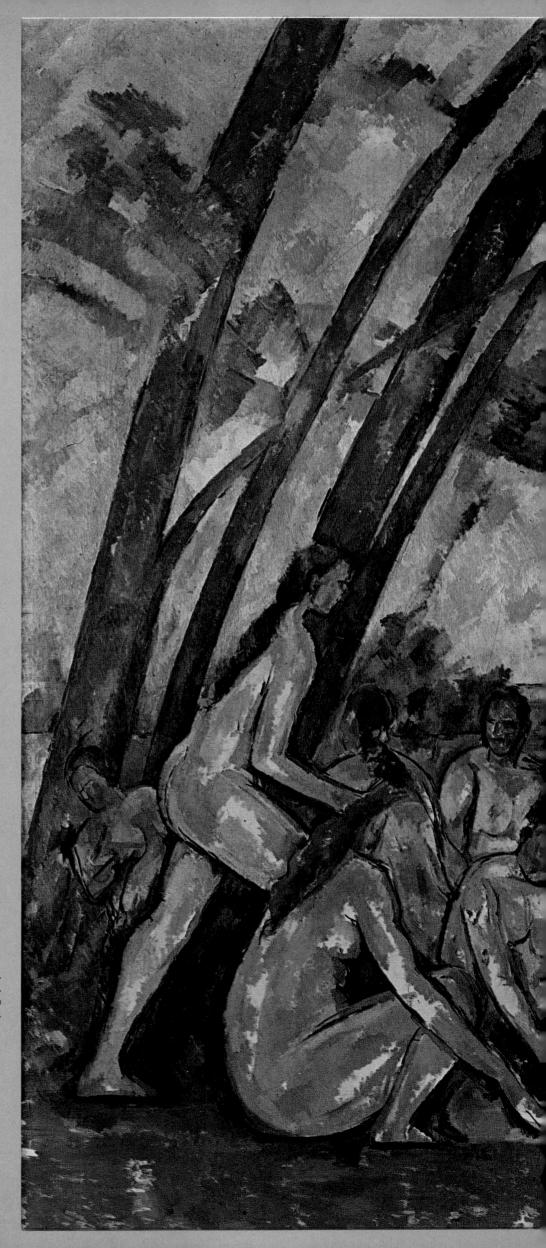

The Large Bathers, 1898–1905.
Canvas, 82 × 98 in.
Philadelphia Museum of Art, Wilstach
Collection.

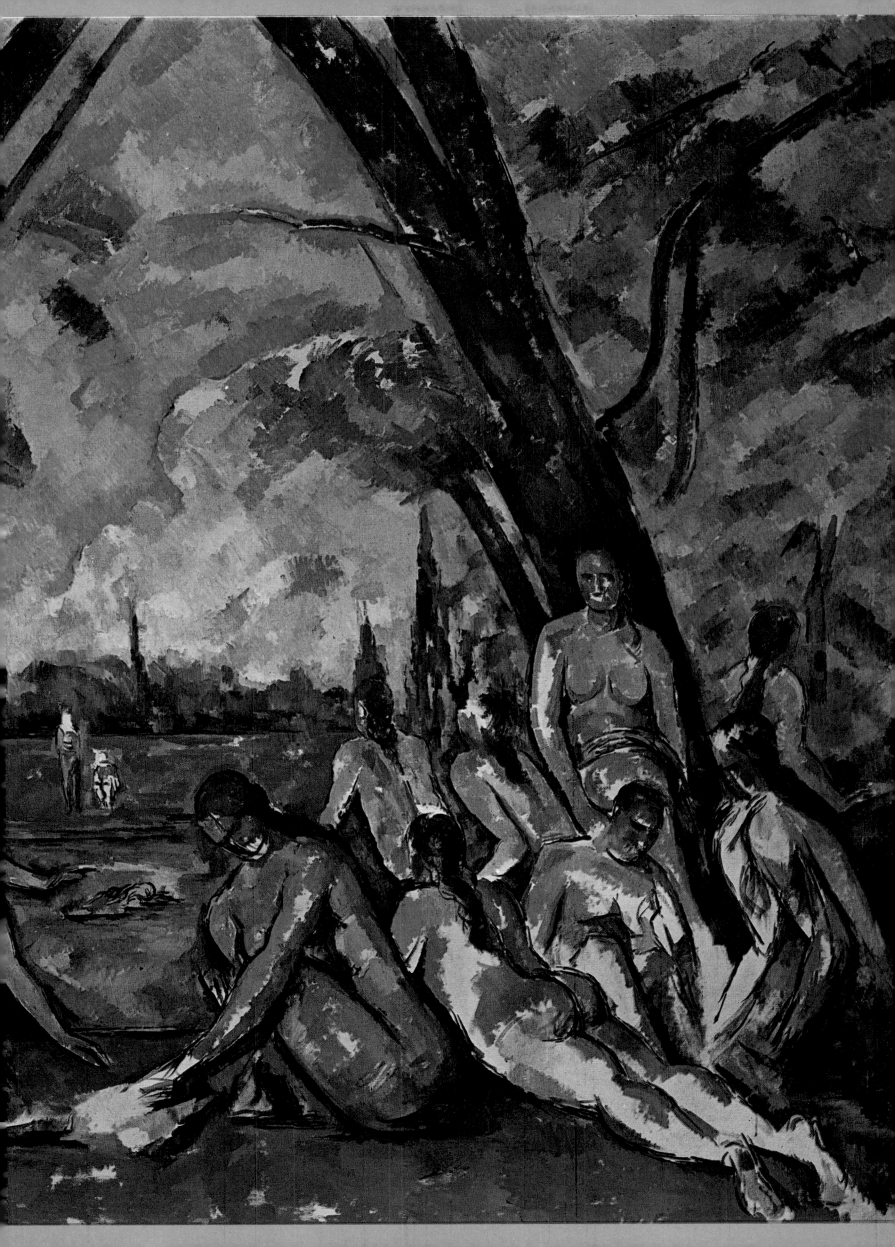

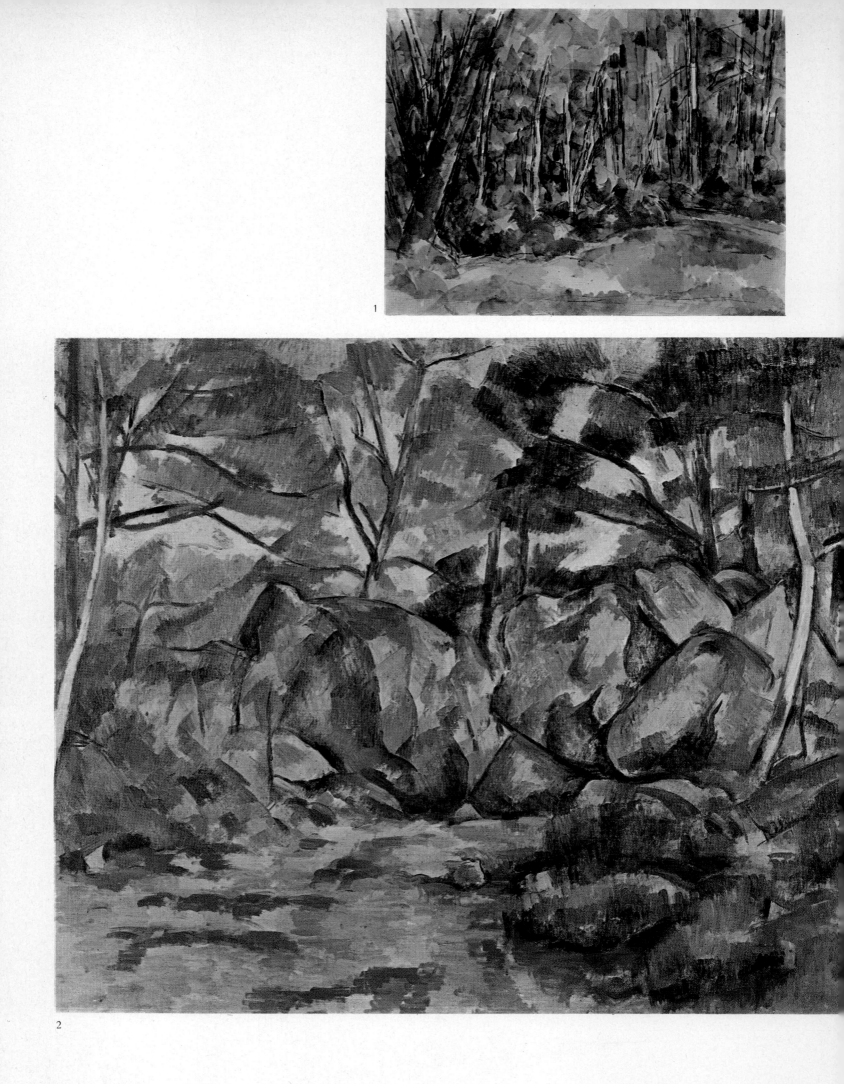

1

2

all their delicacy and spareness, they create an effect of great solidity, with compositional structure comparable to that of his most elaborate oil paintings. Colors are modulated with matchless refinement, freedom, and harmony. "Cézanne's watercolors are amongst the most perfect of his works" (Lord Clark). His watercolors, even more than his oils, exemplify what Kurt Badt has called his "poetic technique."[24] "More vibrant and spontaneous than the oil paintings, yet equally rich in color, the watercolors are at once equally true to nature and more poetic. Because they were more suggestive and they could be handled more freely, they answered perfectly to the demands of his genius" (Bernard Dorival).

His watercolor still lifes, in particular, acquired a sumptuousness that not even his oil paintings could match. Some of the finest date from 1900: *Dessert* (Bernheim de Villers Collection), *Small Jug* (Louvre), *Apples with a Jug and Bottle* (Louvre), and, dominating all the rest in their fascinating virtuosity, *Garment Left on a Chair* (Feilchenfeld Collection, Zurich) and *Skull* (formerly Vollard Collection).

Cézanne visionary temperament, which had found release with such ingenuous and unrestrained turbulence in the inventions of his romantic period, was now under perfect control and enabled him to attain the highest qualities of genuine "expressionism": the infusion of a mysterious tremor of life into inert matter, a suggestion of respiration and movement in motionless objects, an intimation of a supernatural presence in commonplace things, the prefiguration

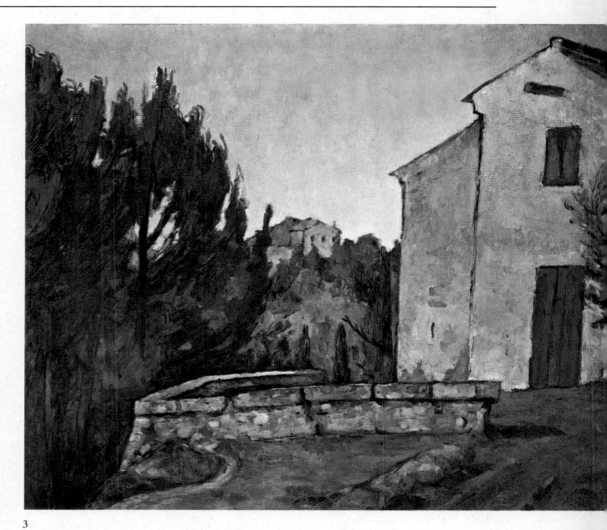

3

of an unsuspected, hallucinatory super-reality beyond material appearances. In this accomplishment, Cézanne was the forerunner of a whole trend of present-day art. Fritz Novotny is right in pointing out that Cézanne's achievement laid the foundations on which much of twentieth-century painting stands, that without him some of its most important developments would be unthinkable.[25]

For Cézanne's landscape painting, watercolors provided an even more favorable medium, because they helped him bring out the essential structure of a site, the peculiar patterns of a group of trees, whether X-shaped (Oskar Reinhart Collection, Winterthur) or V-shaped (Collection of the Princess of Bassiano). The Provençal pine, with its pink trunk and light network of branches, sensitive to the wind and open to the light, was better suited than any other tree to the selective abbreviations of watercolor. Just as Chinese landscape painting reached the height of pure and expressive simplicity in the ink washes

1 Forest, 1890-1900. Watercolor, 17¹/₈ × 22 in. France, Private collection.

2 Woods with Boulders, 1894-1898. Canvas, 19¹/₈ × 23¹/₂ in. Zurich, Kunsthaus.

3 The Abandoned House, 1892-1894. Canvas, 19³/₄ × 24 in. U.S.A., Private collection.

65

1 Woods at Château Noir, c. 1900.
 Canvas, $36^{1}/_4 \times 28^{3}/_4$ in.
 Paris, Musée du Louvre.

2 Study of rocks and trees, 1880–1890.
 Pencil, sheet $4^{7}/_8 \times 8$ in.
 Sketchbook III, p. 19 verso. (Chappuis
 no. 118). Basel, Kupferstichkabinett.

3 Mont Sainte-Victoire, 1904–1906.
 Canvas, $27^{7}/_8 \times 36^{1}/_8$ in. Philadelphia,
 Philadelphia Museum of Art.

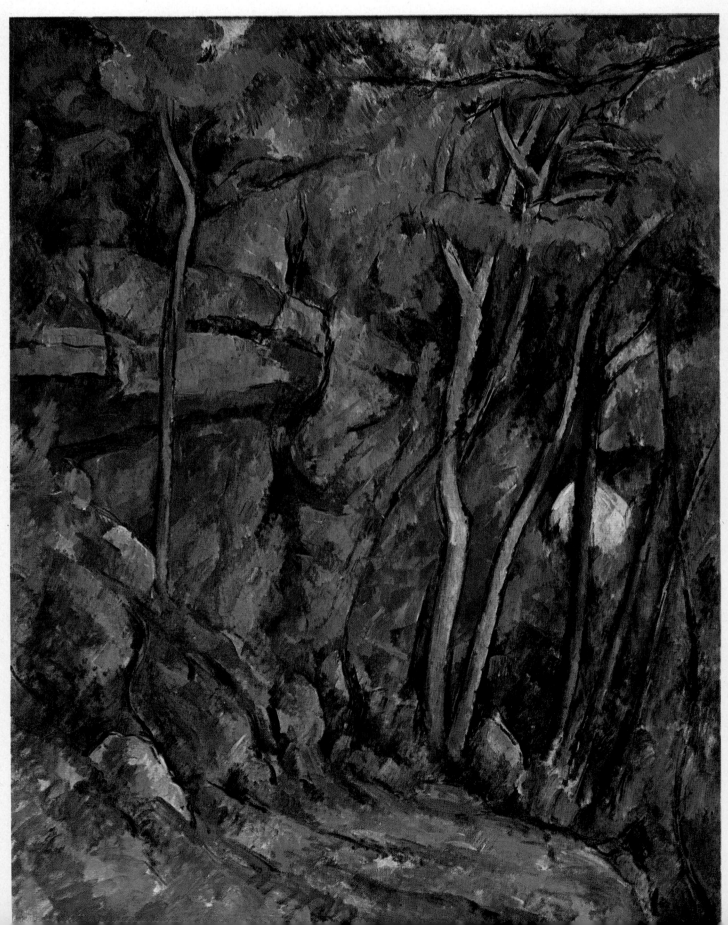

1

2

3

of the Sung Dynasty, so the landscape art of Cézanne reached perfection in the years 1900—1905 in such watercolors as *Pines Shaken by the Wind* and *Pines at Bibémus* (both Sullivan Collection, New York). These are truly worthy to stand beside the grandiose oil paintings of his last period: *Cabanon de Jourdan* (Jucker Collection, Milan), *Château Noir* (Ishibashi Collection, Tokyo) and the several famous views of Mont Sainte-Victoire (Pushkin Museum, Moscow; Kunsthaus, Zurich; Courtauld Institute, London; Philadelphia Museum of Art). There are underlying parallels between the consummate art of Cézanne's last period and the supreme perfection of Sung landscape painting, which not only provided a theme for metaphysical meditation but also sought to convey the very breath and pulse of nature. The Chinese landscapists of the eighth to twelfth centuries followed a course of development curiously paralleling that

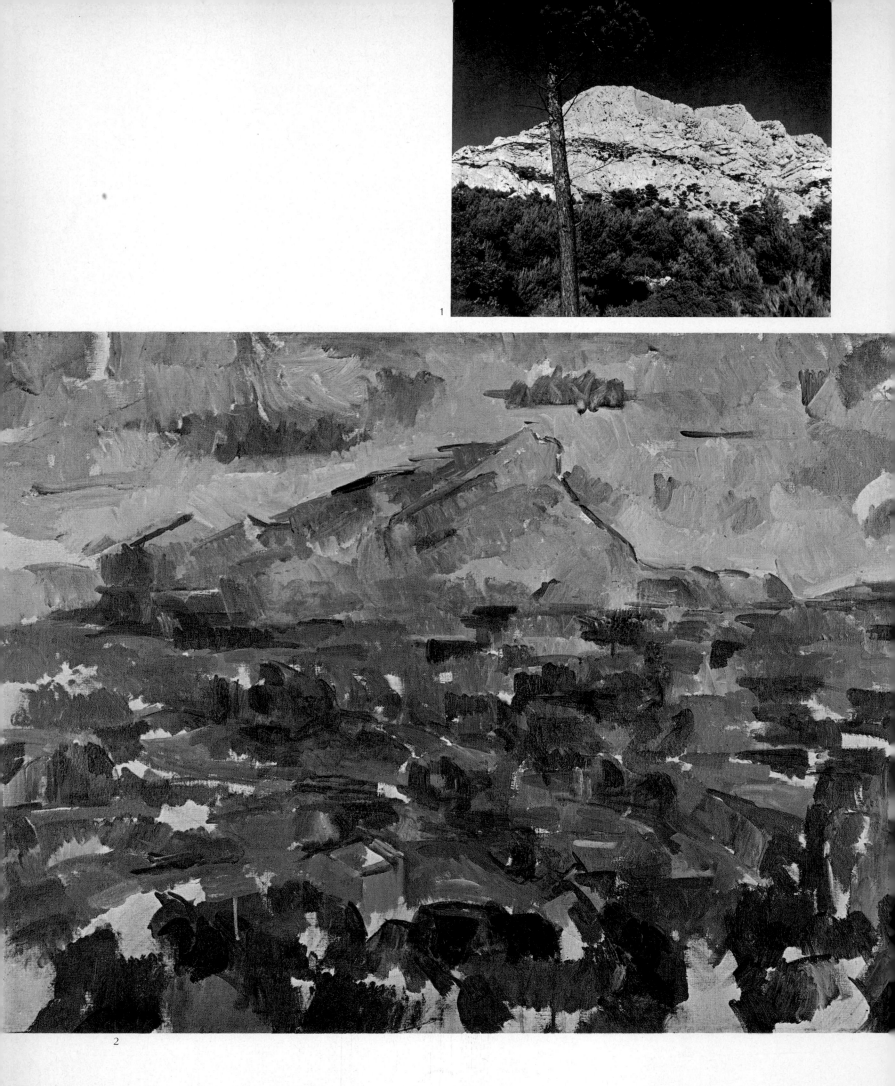

1

2

of Cézanne during the last thirty years of his life. One might even read a philosophical development into those final three decades, but it is difficult to apply that word to so pure an artist as Cézanne. Certainly, there was a far-reaching development of his visual and emotional responses to nature, and to light in particular. One cannot help but recall the last words of the dying Goethe: "More light." And not only do Cézanne's last landscapes glow with this deeper, more intense light; it also suffuses his final portraits: *Portrait of His Gardener Vallier* (Tate Gallery, London) and *Vallier with a Straw Hat* (Leigh B. Block Collection, Chicago), both painted in 1906.

After his great one-man show at Vollard's in 1895, his fame grew steadily. Three Cézannes were shown at the Salon des Indépendants in 1899, and three more were in the Centennial Exhibition at the Paris World's Fair of 1900, one of these being purchased by the National Gallery of Berlin. German museums were the first major institutions to take an interest in his painting.[26] His work was also shown in Berlin and Vienna, and in Paris a large Cézanne exhibition of thirty-three canvases was organized at the 1904 Salon d'Automne. The admiration of the younger generation of painters was symbolized by Maurice Denis' *Homage to Cézanne* (1900), which might have served as a companion piece to Cézanne's own *Homage to Delacroix*, a project he made many sketches for but never actually executed.

Success came late, but in time to show him that his contemporaries were taking an interest in his work. Dealers and collectors began to seek out his long-disdained canvases, and his works began to bring higher prices. At the sale held after Chocquet's death in 1899, seven Cézannes were sold for 17,000 francs. His growing fame made no outward difference in Cézanne's quiet, hard-working, uneventful life style. Over-

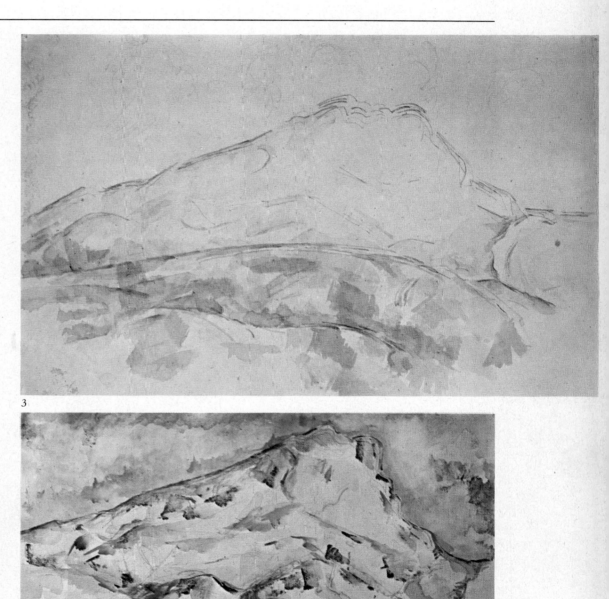

3

4

1 View of Mont Sainte-Victoire, photograph. (Photo San-Viollet)

2 Mont Sainte-Victoire, 1904-1906. Canvas, $25^5/8 \times 31^7/8$ in. Zurich, Kunsthaus.

3 Mont Sainte-Victoire, c. 1902. Watercolor, $12^1/4 \times 18^7/8$ in. U.S.A., Private collection.

4 Mont Sainte-Victoire, c. 1900. Pencil and watercolor, $12^1/4 \times 18^7/8$ in. Paris, Musée du Louvre.

69

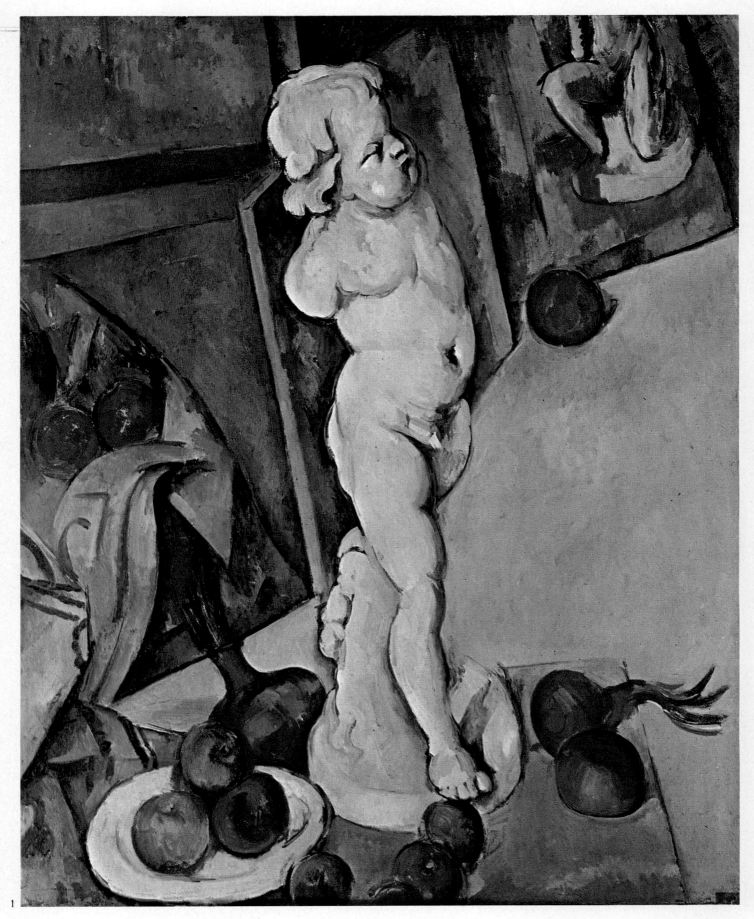

1 **Still Life with Plaster Cupid, c. 1895.**
 Canvas, 28 × 22½ in.
 London, Courtauld Institute Galleries.

2 **Le Cabanon de Jourdan (unfinished),**
 1906. Canvas, 25⅝ × 31⅞ in.
 Milan, Collection of Riccardo Jucker.

coming fatigue, ill health, and old age by sheer effort of will, he went on painting daily in the open country, in his attic studio in Rue Boulegon, and in another studio he had had built just north of Aix, on a country road called the Chemin des Lauves (now renamed Avenue Paul Cézanne). In 1906, though

sixty-seven years old and prematurely aged by diabetes and hard work, only one thing mattered to Cézanne: to achieve, or keep trying to achieve, a clearer and more forceful expression of what Rilke has so well described as "reality raised to the level of the indestructible, as a symbol of what en-

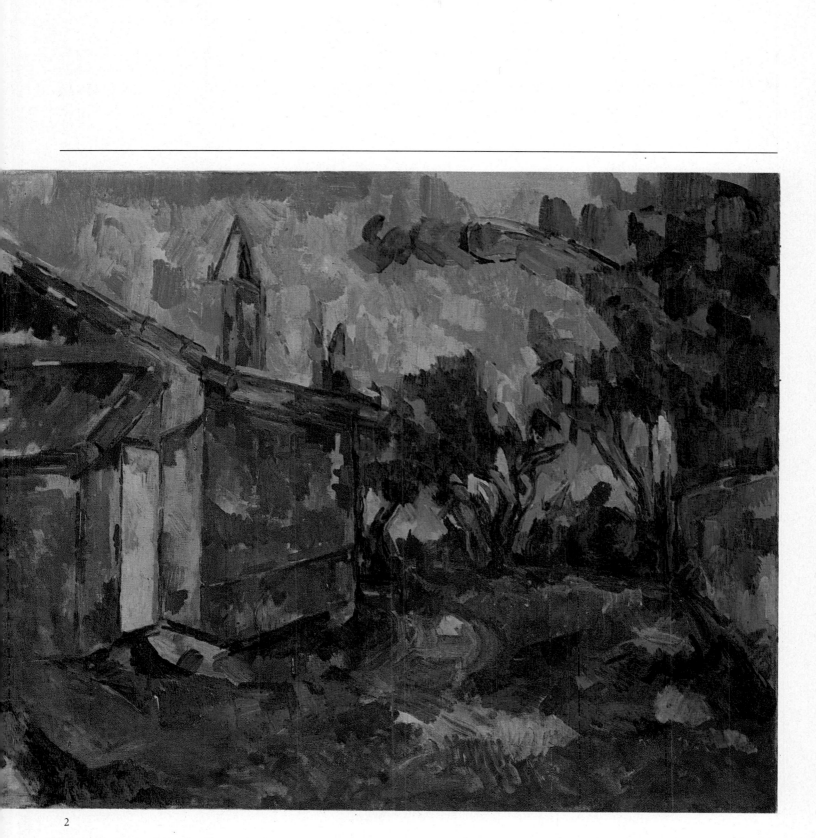

2

dures, transcending all that is perishable."[27] On October 15, 1906, while painting on the road to the village of Le Tholonet, just opposite Mont Sainte-Victoire, Cézanne was caught in a violent rainstorm. Drenched and chilled to the bone, he tried to walk home but collapsed by the roadside. There he was found some time later by the driver of a laundry cart, who picked him up and carried him back to Rue Boulegon. The next day he went out as usual to his studio in the Chemin des Lauves to work on *Cabanon de Jourdan*; the call of an unfinished picture was irresistible. By the time he returned home he was suffering from pneumonia, and the doctor ordered him to bed immediately. But he would not stay there and got up to work on a portrait of his gardener Vallier. He had sworn to die painting, and this vow was almost realized. After a few days of progressive weakness, he died peacefully on October 22, 1906.

NOTES

1. This self-portrait seems to have been painted from a photograph of the young artist taken in the same year, 1861. Painting and photograph are reproduced side by side in John Rewald, *Cézanne, sa vie, son oeuvre, son amitié pour Zola* (Paris, 1939, plates 9 and 10).

2. Cézanne's irritable, anxiety-ridden character may well imply, as Bernard Dorival suggests (*Cézanne*, Paris, 1948), such psychological disturbances as wounded pride and repressed resentments dating back to his childhood.

3. This was, in part, because of the easy material circumstances of his life but also, above all, because of the artist's character and his single-minded purposefulness.

4. Paying a visit one day to the young artist, who showed him his paintings, Gibert indignantly disapproved of them and called them "an outrage against beauty."

5. Up to the 1920's, for instance, the curator of the Aix museum openly expressed his satisfaction at having no pictures by Cézanne and his hope that none would ever enter his museum. These remarks were made in the presence of some Japanese visitors who had come to see the "Cézanne rooms" and were amazed to find no paintings by the Aix master there.

6. Cézanne deliberately emphasized his separateness from the others, by coming to their gatherings in shabby clothes and affecting rough manners and coarse speech. When Manet, trying to be friendly, asked him one day what picture he was working on, he replied: "Un pot de merde" (a shit pot).

7. Émile Bernard's words are quoted by Georges Rivière in his clear and fervent book about the Aix master (*Paul Cézanne, le peintre solitaire*, Paris, 1933): "His genius is a flash that goes deep. I do not shrink from saying that Cézanne is a painter of mystical temperament, and it is a misconception to have always placed him in the deplorable school of naturalism founded by Zola who, in spite of all his blasphemies against nature, has fancifully called himself a naturalist. I say that Cézanne is a painter of mystical temperament because of his purely abstract and aesthetic view of things."

8. René Huyghe (*Cézanne*, Paris, 1936) has pointed out how much the picture of Cézanne changes as we go from one account to another: "There is Émile Bernard's Cézanne: terse and dogmatic, just a bit narrow and limited in his views in comparison with the versatile mind of his interlocutor ... There is Joachim Gasquet's Cézanne: the sober theorist of a moment ago turns into a vibrant, unflagging lyricist, full of sparkling and poetic phrases. There is Vollard's Cézanne, or rather Cézanne as he might have been seen by Alfred Jarry's Père Ubu ... an irascible, fidgety, squeamish puppet, less talkative than the previous ones, since his vocabulary is limited to swear words and arresting turns of phrase. And there is Maurice Denis's Cézanne and Larguier's Cézanne. These, however, in their unexciting sobriety, seem much nearer the truth. But even if we piece these various Cézannes together and fit them into a single pattern, a bit hazy in its outlines, we still know very little about the real Cézanne."

9. The biographies, firsthand reminiscences, and letters are helpful but of limited value. The most important of these items are listed in the accompanying bibliography (p. 94).

10. The book by Kurt Badt (*Die Kunst Cézannes*, Munich, 1956) is one of the most important and intelligent ever written on Cézanne. Its comprehensive scope and the author's insight into the artist's mind, intentions, and achievement make it an indispensable reference for any serious study of Cézanne. Badt writes: "In certain paintings by Cézanne, his personal experiences come to light in more or less disguised form, and I found myself compelled to see and interpret his art from this particular angle, primarily because of its subjective aspects. The result was that his work appeared to me like a 'great confession,' like the works of Goethe and Delacroix, Stendhal and Flaubert, Stifter and Caspar David Friedrich; and its starting point, in the characteristic manner of the nineteenth century, lay in the artist's suffering and his triumph over that suffering."

11. Rather than sadness, one might say gravity, seriousness, melancholy, or a tragic sense of life. Such are the qualities mirrored in the late-medieval painting of Provence (the Avignon *Pietà*, the Boulbon *Christ*) and, nearer to us, in the art of Daumier, Chabaud, and Mathieu-Verdilhan.

12. In the *Railway Cut*, "The device of using screens, which Cézanne was apt to place too abruptly in canvases contemporaneous with this one, results in a flawless rhythmic pattern, thanks to an admirable intuitive sense of the necessary balancings and compensations" (Liliane Guerry, *Cézanne et l'expression de l'espace*, Paris, 1950, 1966).

13. See Paul Cézanne, *Correspondance*, edited and annotated by John Rewald (Paris, 1937).

14. This statement was recorded by the novelist Edmond Jaloux (*Les Saisons littéraires*, Fribourg, Switzerland, 1942), who as a young man knew Cézanne.

15. "This is the painting of a drunken scavenger" (Victor Bunet, 1905). "The most memorable farce of the last fifteen years" (Camille Mauclair in *La Revue Blanche*, 1904). "If Cézanne's painting is accepted, we may as well set fire to the Louvre" (Henri Rochefort in *L'Intransigeant*, March 8, 1903). Moreover, these judgments were made in the last period of Cézanne's life, when he was at the peak of his genius.

16. Roger Fry rightly emphasizes "a most important characteristic of Cézanne's genius, namely, the struggle within him between the Baroque contortions and involutions with which his inner visions presented themselves to his mind, and the extreme simplicity, the Primitive or almost Byzantine interpretation which he gave naturally to the scenes of actual life" (*Cézanne, A Study of his Development*, 2nd. ed., London, 1952). According to those who knew him, these contrasting tendencies of his character and art were to be found even in his face and person. Georges Rivière, writing of Cézanne as he knew him in the 1870's, describes him as "a tall, sturdy fellow perched on rather thin legs. He walked at a steady pace, holding his head up as if looking at the horizon. His noble face, surrounded by a curly beard, recalled the faces of Assyrian gods ... He was usually grave and unsmiling, but when he spoke his face lit up and an expressive mimicry accompanied his words, which he uttered in a loud, ringing voice." According to Edmond Jaloux, "Peasant shrewdness was blended in him with exaggeratedly polite manners."

17. In his letter to Émile Bernard of April 15, 1904, Liliane Guerry is probably right in concluding that this statement reflects the thought, aesthetic, and technique of the "constructive period" and the Gardanne canvases, rather than the spirit and work of his last years. This famous phrase, which became the "cornerstone of cubist theory" (though, as Lord Clark has pointed out, it does not mention cubes at all), refers to Cézanne's preoccupation with spatial construction: "Treat nature according to the cylinder, the sphere, and the cone, with everything put in proper perspective, so that each side of an object or a plane is directed toward a central point." (See the *Correspondance*, Paris, 1937.)

18. Outward events, it should be emphasized, had little effect on Cézanne's work. "No journey or new influence brought about any break" (Liliane Guerry). His development was continuous and unbroken; it was the fruit of an inner process of maturing. No breaks occurred, but only a slow growth of vision and expression, so that each phase of his career blended almost imperceptibly into the next.

19. One is reminded of what Cézanne said to Émile Bernard in his letter of July 25, 1904 (see *Correspondance*, Paris, 1937): "The only way to get on is to study nature. The eye is educated by contact with nature. It becomes concentric by continually looking and working. What I mean is that in an orange, an apple, a ball, a head, there is a culminating point. And in spite of the terrible effect of light and shadow, of coloring sensations, this point is always the one nearest to our eye. The edges of objects recede toward a center located on our horizon. With a little bit of temperament one can be very much a painter."

20. For an instructive comparison between Cézanne's conception of space and that of the Sienese primitives, see Liliane Guerry, *Cézanne et l'expression de l'espace* (Paris, 1950, 1966).

21. When Zola published his novel *L'Oeuvre*, he must have known that Cézanne would recognize himself in many traits of its hero Claude Lantier, a painter who, though dreaming great dreams, is a complete failure and finally commits suicide. For the wordly-minded Zola, an ambitious and highly successful writer, the fact that Cézanne had remained unknown and unrecognized was proof enough that he was a failure. But who reads *L'Oeuvre* today?

22. The Cézanne family is supposed to have come originally from a town in the mountains of western Piedmont, in Italy, called Cesana or Cesena. Their name appears in the seventeenth century in the parish rolls of the French town of Briançon, near the Italian frontier. By 1700 the Cézannes were established in Aix. Among them were cobblers, tailors, and wigmakers. The painter's father, Louis-Auguste Cézanne (1798-1886), was the first to rise to a higher station in life. After prospering as a hatter, in 1848 he took over a bank that had recently failed; under his management it flourished, and he became a rich man.

23. "When color is richest, form is most complete. The secret of drawing and modeling lies in contrasts and relations of tones." These words, written in a letter to Émile Bernard, must be regarded as one of the "golden rules" of Cézanne's aesthetic.

24. Technique and poetry are inseparable, and his poetry may be said to result from his very technique. This point has been perceptively dealt with by Kurt Badt (*Die Kunst Cézannes*, Munich, 1956).

25. See Novotny's preface to the catalogue of the monumental Cézanne exhibition held in Munich in 1956.

26. Karl Ernst Osthaus, a German collector and founder of the Folkwang Museum in Essen, paid a visit to Cézanne in 1906 to buy some canvases for his museum. Osthaus has left an extremely interesting account of this meeting and what Cézanne said to him. An English translation of his account is given in John Rewald, *Paul Cézanne* (New York, 1948).

27. Rainer Maria Rilke, *Briefe über Cézanne* (Wiesbaden, 1952).

Documentation

Cézanne year by year

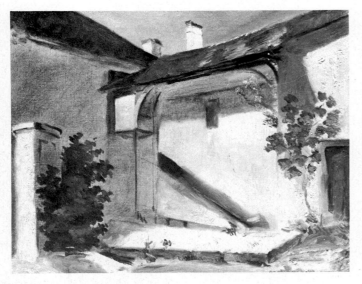

1860–1865
Farmyard. Canvas, 10¹/₄ × 13 in. U.S.A., Private collection.

1867
Uncle
Dominique.
Canvas,
31¹/₂ × 25¹/₄ in.
Switzerland,
Private
collection.

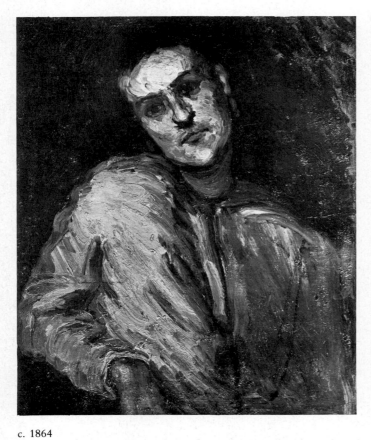

c. 1864
The Artist's Sister. Canvas, 23⁵/₈ × 21¹/₄ in. Private collection.

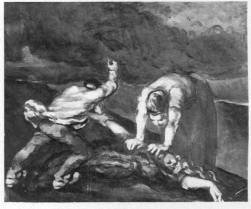

1867–1870
The Crime.
Canvas,
25¹/₄ × 31⁷/₈ in.
Private
collection.

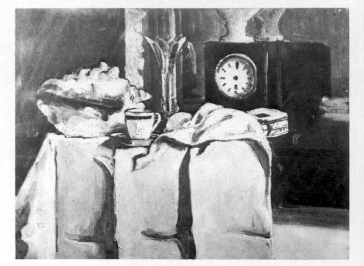

1869–1871
The Black Clock. Canvas, 21¹/₄ × 28³/₄ in.
France, Private collection.

1872–1873
Underbrush in the Forest of Fontainebleau.
Canvas, 18¹/8 × 21⁵/8 in. U.S.A., Private collection.

1873–1877
Legendary Scene, or Sancho Panza in the Water.
Canvas, 18¹/8 × 21⁵/8 in. Private collection.

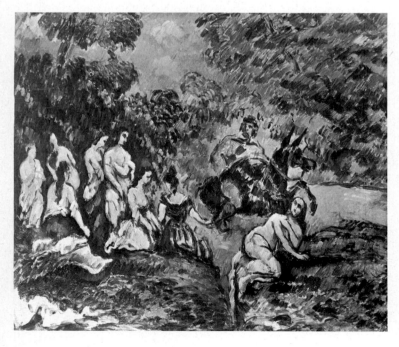

1873–1877
Tiger. Canvas, 11¹/2 × 14¹/2 in. Private collection.

1873–1877
Madame Cézanne Sitting at a Table.
Canvas, 18¹/8 × 15 in. Private collection.

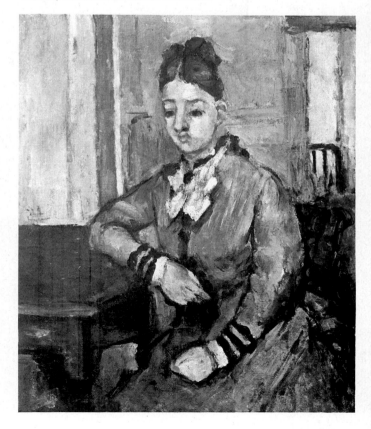

1873-1877
Pontoise.
Canvas, $21^{1}/_{4} \times 25^{5}/_{8}$ in.
Private collection.

1875-1877
Nude in a Landscape.
Canvas, $11^{3}/_{4} \times 6^{3}/_{4}$ in.
Private collection.

1875-1877
View of Auvers through the Trees.
Canvas, $23^{5}/_{8} \times 19^{5}/_{8}$ in. U.S.A., Private collection.

1875-1877
Vase of Flowers. Canvas, $14^{5}/_{8} \times 12^{5}/_{8}$ in.
Private collection.

1875-1877
Three Bathers.
Canvas, $9^{7}/_{8} \times 13^{3}/_{8}$ in.
Private collection.

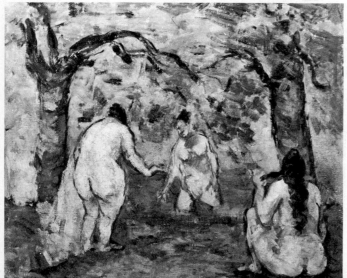

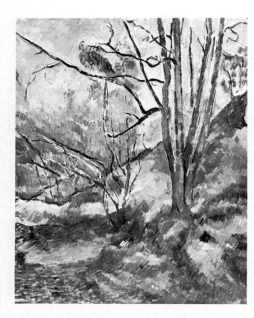

1879–1882
Forest. Canvas,
21⁵/₈ × 18¹/₂ in.
Private collection.

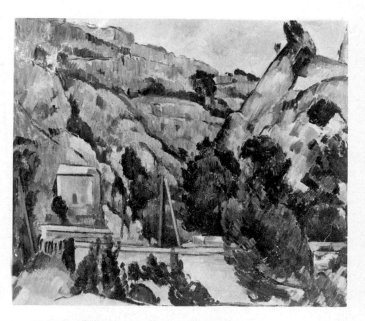

1879–1882
Uphill Road.
Canvas,
23¹/₄ × 28 in.
Private collection.

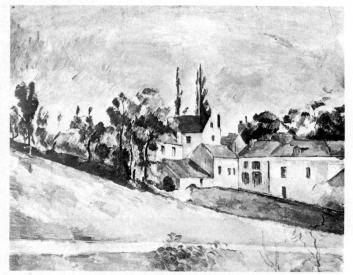

1882–1885
Viaduct at
L'Estaque.
Canvas,
17³/₈ × 20⁷/₈ in.
Private collection.

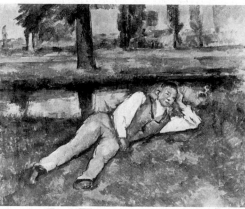

1882–1887
Man Lying on
the Ground.
Canvas,
21¹/₄ × 25⁵/₈ in.
Private collection.

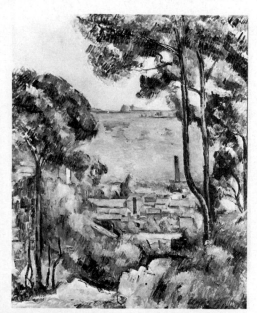

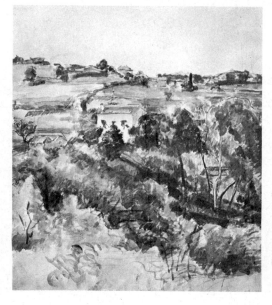

1882–1885
L'Estaque.
Canvas,
28³/₄ × 23⁵/₈ in.
England, Private
collection.

1883–1887
Landscape near
Melun.
Watercolor,
14¹/₈ × 11³/₄ in.
U.S.A., Private
collection.

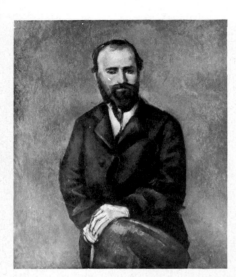

1883-1887
Self-Portrait.
Canvas, 21⁵/8 × 18¹/8 in.
Basel, Rudolf Staechelin
Collection.

1883-1887
Cherries and Peaches.
Canvas, 19³/4 × 24 in.
Los Angeles, County
Museum of Art.

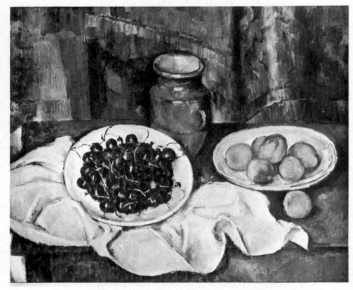

1885-1887
Apples. Canvas, 15 × 18¹/8 in.
Private collection.

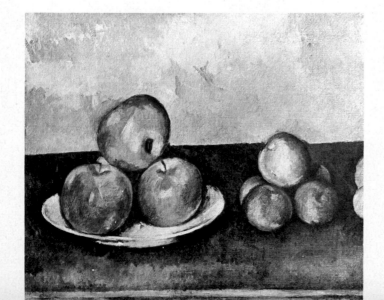

1885-1887
Chestnut Trees at Jas de Bouffan in Winter. Canvas, 28³/4 × 36¹/4 in.
Minneapolis, The Minneapolis Institute of Arts.

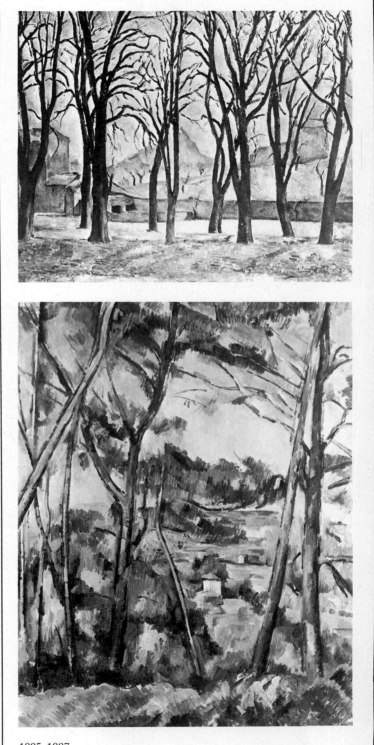

1885-1887
The Plain of the Arc. Canvas, 31⁷/8 × 25⁵/8 in.
U.S.A., Private collection.

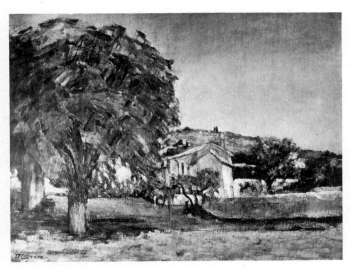

1885-1887
Chestnut Trees and Farmhouse at Jas de Bouffan. Canvas, 25⁵/₈ × 31⁷/₈ in. France, Mme. Florence Gould Collection.

c. 1888
Banks of the Marne. Canvas, 19³/₄ × 24 in. Private collection.

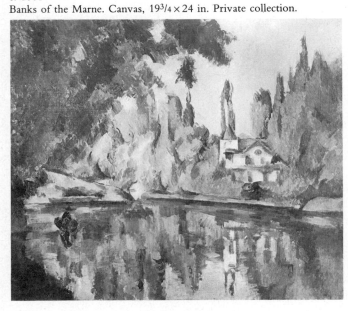

1888-1890
Water and
Foliage.
Canvas,
29¹/₂ × 24³/₄ in.
Private collection.

1892-1894
Ruined House. Canvas, 25⁵/₈ × 21¹/₄ in.
U.S.A., Private collection.

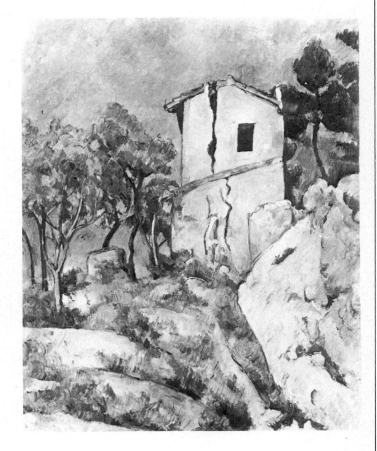

c. 1895
Standing Female Nude. Canvas, 36⁵/₈ × 28 in.
Switzerland, Private collection.

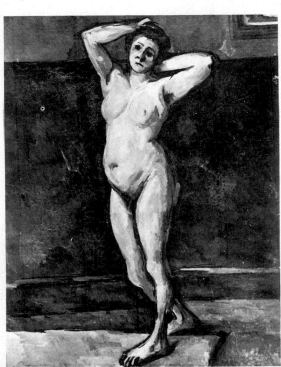

79

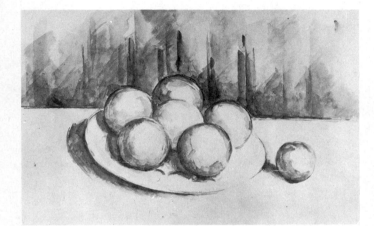

1895–1900
Oranges on a Plate. Watercolor, 12¹/₄ × 18⁷/₈ in.
Private collection.

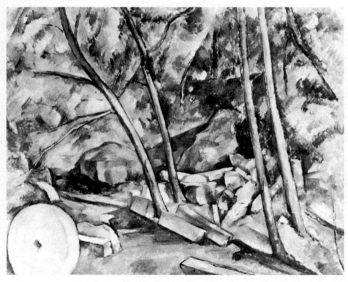

1898–1900
The Millstone.
Canvas,
28³/₄ × 36¹/₄in.
Philadelphia,
Museum of Art,
Mr. and Mrs.
Carroll S. Tyson
Collection.

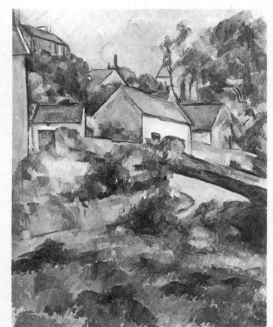

1899
Montgéroult at
Sunset.
Canvas,
31⁷/₈ × 25⁵/₈ in.
Private collection.

1900–1904
Bathers. Watercolor, 4³/₄ × 7¹/₂ in. Private collection.

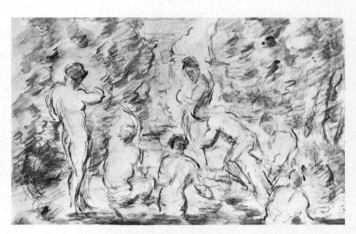

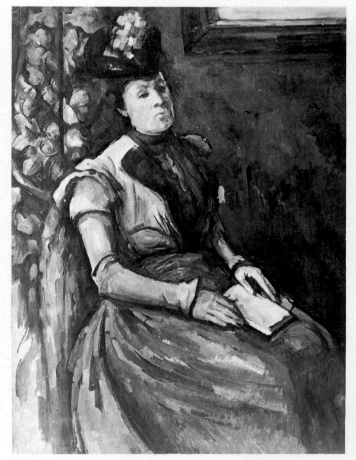

1900–1904
Woman with a Book. Canvas, 25⁵/₈ × 19³/₄ in.
Private collection.

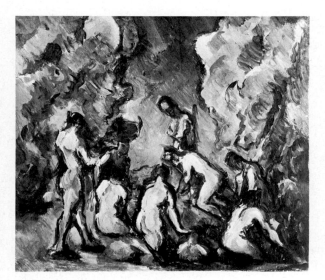

1900-1904
Bathers. Canvas, 9 1/2 × 10 5/8 in.
Private collection.

1904
View of Mont Sainte-Victoire. Watercolor, 13 × 9 7/8 in.
U.S.A., Private collection.

1904-1906
Apples, Goblet, Bottle, and Chairback. Watercolor, 24 1/4 × 29 3/8 in.
Private collection.

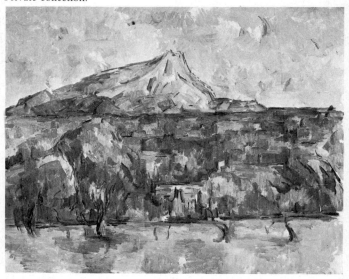

1904-1906
Mont Sainte-Victoire. Canvas, 25 1/2 × 32 in.
Kansas City (Mo.), Nelson Gallery and Atkins Museum, Nelson Fund.

1906 Still Life. Watercolor, 18 1/2 × 24 1/2 in. Private collection.

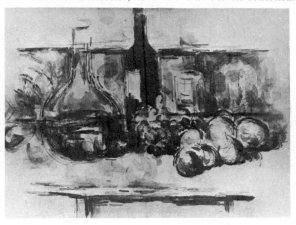

Cézanne and modern art

Cézanne's influence was of a wholly different nature from that of Impressionism in general and only began to take effect some years later, through such painters as Gauguin, Émile Bernard, and Maurice Denis, who found in his work a welcome reaction against Impressionism. From the 1890's on, his influence grew steadily. Very soon it became so strong and pervasive that virtually all the experiments which gave rise to modern art in the first quarter of the twentieth century can be traced back to Cézanne. His work provided their point of departure and the justification for their boldest innovations.

After the Fauves, the Cubists found in Cézanne's example the guidelines they needed for their sweeping renewal of aesthetic and technical principles. Even the artists who kept aloof from these fairly extreme positions and maintained a more traditional contact with nature took inspiration from Cézanne, not from Impressionism. In his art they found models for a new conception of space, rendered by means

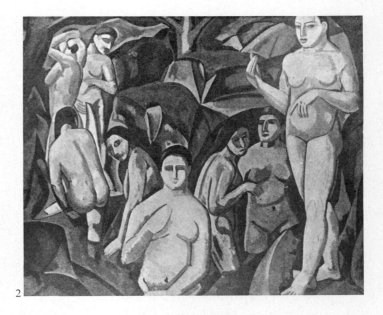

2 André Derain (1880–1954): Bathers, 1908. Canvas, 71 × 88¹/₂ in. Private coll.

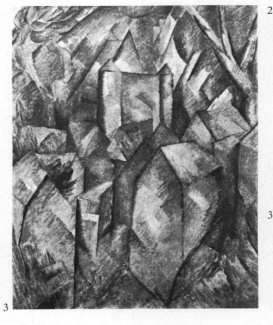

3 Georges Braque (1882–1963): La Roche-Guyon, 1909. Canvas, 29¹/₈ × 23⁵/₈ in. France, Private coll.

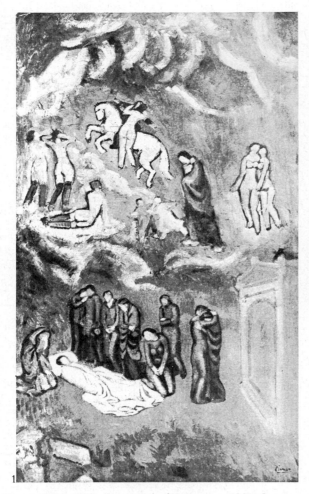

1 Pablo Picasso (1881–1973): The Burial of Casagémas, 1901. Canvas, 59 × 35¹/₂ in. Paris, Musée d'Art Moderne.

of color rather than through linear perspective; for a return to composition, to a classical organization of the picture plane; for a renewed concern with structure and stability in landscape painting, whereas the Impressionists had been most intent on fleeting effects; for elimination of picturesque accessories or sentimental overtones in order to give priority to basic pictorial values, especially in portraiture.

Nothing is more indicative of Cézanne's single-minded concentration on transposing the motif into a picture than a remark to his mother while painting a portrait of her: "I want you to pose like an apple." There would then be nothing to distract him from purely pictorial considerations.

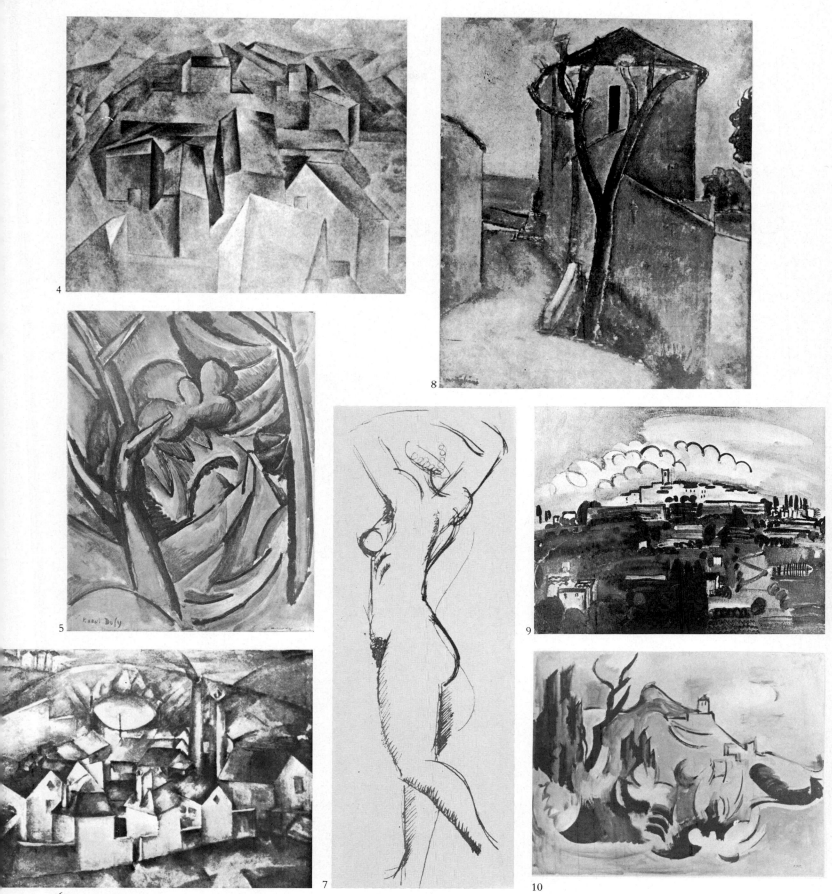

For some half a century, his work, so misjudged in his lifetime, served as a pretext and an example for the boldest and most contradictory endeavors. It freed modern art from the constraints of academicism, but at the same time showed how much the artist must depend on disciplined effort in order to transform material reality into pictorial reality.

R.C.

4 Pablo Picasso (1881-1973): Houses on the Hill, Horta de Ebro, 1909. Canvas, $25^5/8 \times 31^7/8$ in. France, Private coll.

5 Raoul Dufy (1877-1953): The Green Trees, 1909. Canvas, $21^5/8 \times 18^1/8$ in. Private collection. (Photo Karquel)

6 Henri Hayden (1883): The Factory, 1912. Canvas, $23^5/8 \times 31^7/8$ in. Collections of the Leeds City Art Galleries.

7 Roger de La Fresnaye (1885-1925): Standing Nude in Side View, with Upraised Arms, 1912. Pen drawing, $12^5/8 \times 9^7/8$ in. France, Private collection.

8 Amedeo Modigliani (1884-1920): Landscape in Provence, 1917-1918. Canvas, $21^5/8 \times 18^1/8$ in. France, Private coll. (Photo Galerie Charpentier)

9 Raoul Dufy (1877-1953): View of Saint-Paul, 1920. Canvas, Private collection.

10 André Lhote (1885-1961): Landscape in the Drôme, 1928. Oil on paper, $21^1/2 \times 27^3/4$ in. France, Private collection.

Cézanne's drawings

The Kunstmuseum in Basel owns the largest and most varied collection of Cézanne drawings: 141 sheets (70 of them with drawings on both sides), holding 211 drawings from three sketchbooks. These have been studied, classified, and published by Adrien Chappuis in his book *Les Dessins de Paul Cézanne au Cabinet des Estampes du Musée des Beaux-Arts de Bâle* (Urs Graf Verlag, Olten-Lausanne, 1962). Instead of keeping to the order of the pages in each sketchbook, which is of dubious validity, Chappuis chose to work out, as far as possible, a chronological order based on the character and style of the drawings, grouping together similar or related subjects assignable to the same period. This arrangement, so carefully and convincingly worked out, has been accepted here because it follows a logical sequence that parallels the evolution of the paintings and, as the author rightly says, "reflects fairly closely the whole body of drawings left by Cézanne."

Thus arranged, the Basel drawings fall into three main periods: an early period of youthful work up to about 1870/1872, comprising about 60 drawings; then a distinctly Impressionist period from about 1872 to 1878/1880, comprising the next 40 drawings (to about no. 100); and, finally, a third period in which the artist's characteristic personality asserts itself ever more strongly, together with his highly particular sense of forms in relation to light. In reproducing the drawings, we have kept to the numbering, titles, and chronological order of the Chappuis catalogue, which is clearly based on a close and exacting knowledge of Cézanne's work; of necessity, we have not included those drawings which would have appeared indistinct in small-size reproductions.

R.C.

1 Three sketches, 1865-67. Pen, sh. $7^{1}/4 \times 5^{5}/8$ in. KK inv. 1934.174 (no. 2).

2 Studies with scenes of violence, 1864-67. Pencil, sh. $9 \times 13^{3}/4$ in. KK inv. 1934.192 (no. 4).

3 Marion and Valabrègue, 1866. Pencil, sh. $11 \times 7^{1}/2$ in. KK inv. 1934.200 (no. 5).

4 Rear view of painter, 1866-70. Pencil, sh. 9×7 in., sk. $7^{1}/8 \times 9^{1}/2$ in. KK inv. 1934.163 v. (no. 7).

5 Two heads and two figures, 1866. Pencil and India ink, sh. $9^{3}/8 \times 7$ in., sk. $7^{1}/8 \times 9^{1}/2$ in. KK inv. 1934.161 v. (no. 8).

6 Figure with umbrella, 1866-71. Pencil highlighted with white crayon, sh. $5^{5}/8 \times 6^{5}/8$ in., sk. $7^{1}/8 \times 9^{1}/2$ in. KK. inv. 1934.151 (no. 11).

7 Portrait of Delacroix with other studies, 1864-68? Pencil and India ink, sh. $9^{3}/8 \times 7$ in., sk. $7^{1}/8 \times 9^{1}/2$ in. KK inv. 1934.164 (no. 13).

8 Studies for "The Orgy," 1864-68. Pencil, sh. $7 \times 9^{1}/4$ in., sk. $7^{1}/8 \times 9^{1}/2$ in. KK inv. 1934.182 (no. 15).

All the drawings reproduced here belong to the Kupferstichkabinett (Print Room) of the Basel Kunstmuseum. The number in parentheses at the end of each caption refers to the Chappuis catalogue: sh. stands for sheet, sk. for sketchbook, v. for verso.

9 Studies for "The Orgy,"
 1864–68. Pencil and white
 gouache, sh. 7 × 9¹/₂ in., sk.
 7¹/₈ × 9¹/₂ in. KK inv. 1934.178
 v. (no. 16).

10 Study for "The Orgy" and
 plein-air painter, 1864-68.
 Pencil, sh. 9³/₈ × 7 in., sk.
 7¹/₈ × 9¹/₂ in. KK inv. 1934.
 166 (no. 17).

11 Male nude, 1863-70 Charcoal
 and white gouache, sh.
 9³/₄ × 11³/₄ in. KK inv.
 1934.196 (no. 18).

12 Nude studies, 1867-70.
 Charcoal and pencil, sh.
 16¹/₄ × 11³/₄ in. KK inv.
 1934.206 v. (no. 19).

13 Studies after Fra Bartolomeo:
 Christ, 1866-71. Pencil, sh.
 7 × 9¹/₂ in., sk. 7¹/₈ × 9¹/₂ in.
 KK inv. 1934.178 (no. 21).

14 After Signorelli: Male nude,
 1866-72. Pencil, sh. 9¹/₂ × 6⁷/₈
 in., sk. 7¹/₈ × 9¹/₂ in. KK inv.
 1934.177 v. (no. 22).

9

15 After Murillo: St. Diego in the
 Angels' Kitchen, 1866-70.
 Pencil, sh. 9¹/₈ × 7 in., sk.
 7¹/₈ × 9¹/₂ in. KK inv.
 1934.182 (no. 23).

16 After Passarotti, Domenichino,
 and an unknown master,
 1866-71. Pencil, sh. 7 × 9 in.,
 sk. 7¹/₈ × 9¹/₂ in. KK inv.
 1934.176 (no. 24).

17 Mother and Child, ornamental
 vase, and woman, 1866-71.
 Pencil, sh. 7 × 9³/₈ in., sk.
 7¹/₈ × 9¹/₂ in. KK inv.
 1934.169 (no. 25).

11

12

13

14

15

16

17

18 Mitred bishop, after an
 unidentified master,
 1866-67. Pencil (with
 ciphers in ink), sh.
 9¹/₂ × 6⁷/₈ in., sk.
 7¹/₈ × 9¹/₂ in. KK inv.
 1934.181 v. (no. 26).

19 After Veronese: Esther and
 Lot's daughter, 1866-71.
 Pencil, sh. 9¹/₂ × 6⁷/₈ in.,
 sk. 7¹/₈ × 9¹/₂ in. KK inv.
 1934.77. (no. 27).

20 After Veronese: Wedding
 at Cana, 1866-71. Pencil,
 sh. 7 × 9 in., sk. 7¹/₈ × 9¹/₂
 in. KK inv. 1934.172 (no.
 28).

19

20

18

21

22

24

23

25

26

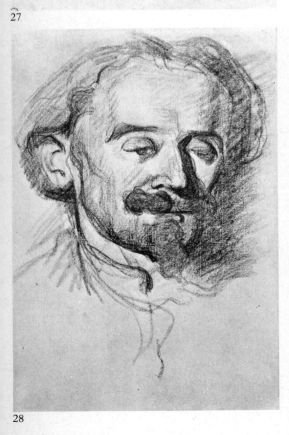

27

28

21 After Giulio Romano and an unknown master: Two figures, 1868-75. Pencil, sh. 9½ × 7 in., sk. 9½ × 7⅛ in. KK inv. 1934.181 v. (no. 34).

22 Woman kneeling by a coffin, 1867-77. Pencil, sh. 9¼ × 7 in., sk. 7⅛ × 9½ in. KK inv. 1934.162 v. (no. 36).

23 Two men with staffs and studies for "Woman Kneeling by a Coffin," 1866-67. Pencil, sh. 7 × 9 in., sk. 7⅛ × 9½ in. KK inv. 1934.163 (no. 38).

24 Sketch for "The Rape," 1867-71. Pencil, sh. 4 × 6¾ in., sk. 4⅛ × 6¾ in. KK inv. 1934.157 v. (no. 44).

25 Five figures, 1866-70. Pencil, sh. 5⅞ × 7¼ in. KK inv. 1934.148 (no. 46).

26 Tree and house, 1868-71. Pencil, sh. 5⅞ × 7⅛ in. KK inv. 1934.168 (no. 47).

29

31



30

27 Towel draped over back of a chair, 1865-75. Pen and India ink wash, ocher, and pencil, sh. 7 × 9½ in., sk. 7⅛ × 9½ in. KK inv. 1934.165 v. (no. 48).

28 Head of the painter Achille Emperaire, 1867-70. Charcoal, sh. 17 × 12½ in. KK inv. 1951.100 (no. 50).

29 Reading: Zola and Alexis, 1869-70. Pencil, sh. 5⅝ × 7¾ in. KK inv. 1934.180 v. (no. 54).

30 Man, woman, and roof with chimneys, 1870-75. Pencil, ink, and watercolor, sh. 5¼ × 8⅛ in. KK inv. 1934.184 (no. 57).

31 People in a boat, 1870-75. Pencil, sh. 4 × 6⅝ in., sk. 4 × 6¾ in. KK inv. 1935.175 (no. 58).

32 Four men sitting under a tree, 1871-77. Pencil, sh. 4 × 6⅝ in., sk. 4 × 6¾ KK inv. 1935.174 (no. 59).

32

33

34

33 Tired horse, 1870-75. Pencil, sh. 4 × 6¾ in., sk. 4 × 6¾ in. KK inv. 1934.154 (no. 63).

34 Pipe smoker and erotic scene, 1872-74. Pencil, sh. 4 × 6⅝ in., sk. 4 × 6¾ in. KK inv. 1935.174 v. (no. 69).

35 Couple, study for "Afternoon in Naples," c. 1872-76. Pencil, sh. 5½ × 11¾ in. KK inv. 1934.212 (no. 71).

35

36

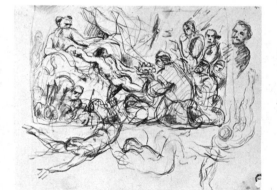
37

38

36 Female nude, study for "Afternoon in Naples," 1872-75. Pencil, sh. 3½ × 5⅝ in. KK inv. 1934.153 (no. 73).

37 Bearded man holding a whip, 1870-77. Pencil, sh. 6¾ × 4 in., 4⅛ × 6¾ in. KK inv. 1934.157 (no. 76).

38 Painter, 1867-72. Pencil, sh. 6¾ × 4⅛ in., sk. 4⅛ × 6¾ in. KK inv. 1934.150 (no. 77).

39 Frenhofer showing his masterpiece, 1867-72. Pencil, and ink, sh. 4⅛ × 6¾ in., sk. 4⅛ × 6¾ in. KK inv. 1934.158 (no. 78).

40 Study for "The Eternal Feminine," 1870-75. Pencil, sh. 7 × 9¼ in., sk. 7⅛ × 9½ in. KK inv. 1934.162 (no. 79).

41 Landscape with houses and trees, 1872-75. Pencil, sh. 7¼ × 8¾ in. KK inv. 1934.179 (no. 85).

42 Hills with houses and trees, 1870-74. Pencil, sh. 12¼ × 18⅝ in. KK inv. 1934.207 v. (no. 86).

39

40

41

42

43

44

45

46

47

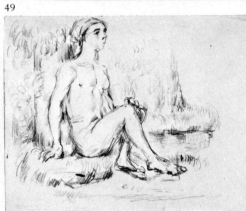

49

51

43 Landscape at Médan, 1877–82. Pencil, sh.
 10³/8 × 11³/4 in. KK inv. 1934.205 (no. 87).
44 Landscape, 1876–80. Pencil, sh. 8⁵/8 × 11³/4 in.
 KK inv. 1934.190 (no. 88).
45 Heads after various old masters, 1877–82. Pencil.
 7⁷/8 × 11⁷/8 in. KK inv. 1934.202 v. (no. 89).

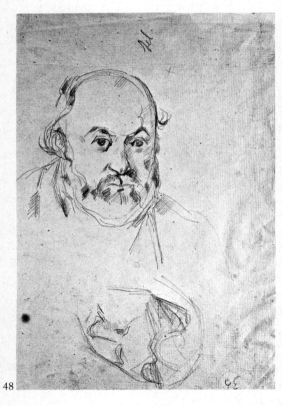

48

50

52 53

46 Heads of a boy and copy after 48 Self-Portrait and sketch of 50 Bather sitting by the water, 52 Still life with candlestick, c.
 Pareja, 1877–82. Pencil, sh. face, 1878–85. Pencil, sh. 1872–77. Pencil, sh. 5³/4 × 7³/4 1880–82. Pencil, 5 × 7³/4 in.,
 12³/4 × 9⁷/8 in. KK inv. 12 × 8 in. KK inv. 1934.191 in. KK inv. 1934.210 (no. 97). sk. III, p. 17. KK inv.
 1934.188 (no. 90). (no. 93). 51 Head of the artist's son, 1935.185 (no. 104).
47 Three heads and a sleeve, 49 Bather drying himself, 1880–82. Pencil, sh. 6³/4 × 6¹/2 53 Still life with carafe, 1882–92.
 1877–82. Pencil, sh. 1879–82. Pencil, sh. 9 × 11 in. in. KK inv. 1934.209 (no. 99). Pencil, sh. 7⁷/8 × 4³/4 in., sk.
 9⁷/8 × 12³/4 in. KK inv. KK inv. 1934.189 (no. 94). II, p. 33. KK inv. 1935.183
 1934.188 v. (no. 92). (no. 106).

54 Lycian Apollo, after ancient
 statue, c. 1882. Pencil, sh.
 8¹/₄ × 4³/₄ in., sk. II, p. 52. KK
 inv. 1935.139 (no. 107).
55 After P. Julien: The nymph
 Amalthea, c. 1882. Pencil, sh.
 8¹/₄ × 4³/₄ in., sk. II, p. 48. v.
 KK inv. 1935.146 (no. 108).
56 Male nude, 1884–90.
 Charcoal, sh. 16¹/₄ × 11³/₄ in.
 KK inv. 1934.206 (no. 110).
57 Bather in rear view, 1882–90.
 Pencil, sh. 4³/₄ × 7 in., sk. III,
 p. 18. KK inv. 1935.170 (no.
 112).
58 After Mino da Fiesole:
 Giovanni de' Medici, c. 1882.
 Pencil, 8¹/₈ × 5¹/₈ in., sk. I, p.
 21. KK inv. 1935.124 (no.
 114).
59 After Benedetto da Maiano:
 Filippo Strozzi, c. 1882.
 Pencil, sh. 8³/₈ × 5¹/₈ in., sk. I,
 p. 3 v. KK inv. 1935.123 (no.
 115).

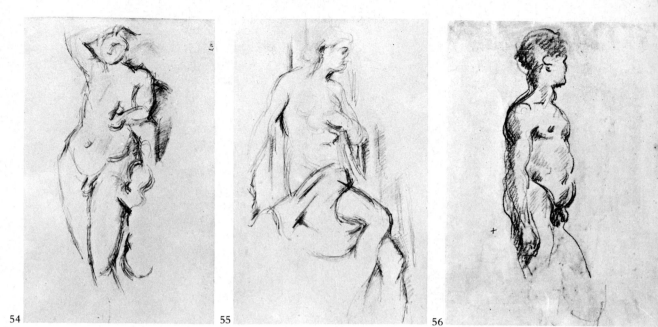

54 55 56

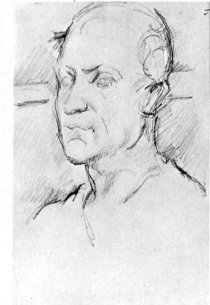

57

58 59

60

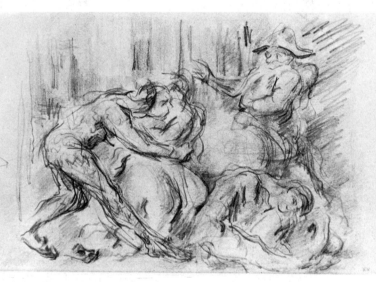

63

1 62

60 Landscape with hills and
 house, 1882–85. Pencil, sh.
 4⁷/₈ × 7³/₄ in., sk. III, p. 26.
 KK inv. 1935.179 (no. 119).
61 Beatrice of Aragon, after
 Florentine bust, 1882–86.
 Pencil, sh. 8¹/₈ × 5¹/₈ in., sk. I,
 p. 9 KK inv. 1935.132 (no.
 121).

62 African fisherman, after
 ancient statuary, c. 1885.
 Pencil, sh. 8³/₈ × 5¹/₈ in., sk. I,
 p. 6 KK inv. 1935.141 (no.
 122).
63 Study for carnival scene,
 1885–90. Pencil, sh. 5⁷/₈ × 9¹/₄
 in., sk. III, p. 20. KK inv.
 1935.178 (no. 124).

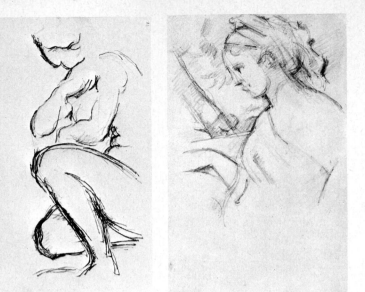

64 Crouching Venus, after ancient statuary, c. 1885. Pencil, sh. 8¹/₄ × 4³/₄ in., sk. II, p. 9. KK inv. 1935.145 (no. 126).

65 After Poussin: Arcadian shepherdess, 1886-96. Pencil, sh. 8 × 4³/₄ in., sk. II, p. 47. KK inv. 1935.155 (no. 128).

66 Two bathers resting, 1885-95. Pencil and watercolor, sh. 5 × 8 in., sk. III, p. 9. KK inv. 1935.171 (no. 132).

67 Spectators, 1886-96. Pencil, sh. 5 × 8 in., sk. III. KK inv. 1934.212a (no. 136).

68 Three bathers, 1886-90. Pencil highlighted with watercolor, sh. 5 × 8¹/₈ in., sk. III, p. 29. KK inv. 1935.173 (no. 140).

69 Bather with hands behind his neck, 1882-88. Pencil, sh. 5 × 3³/₄ in., sk. III, p. 6 (left side). KK inv. 1935.168 (no. 141).

70 Male nude with upraised arms, 1883-88. Pencil, sh. 8¹/₄ × 4³/₄ in., sk. II, p. 36. KK inv. 1935.160 (no. 142).

64 65 66

67 68

69

71

71 After Rude: Young Neapolitan fisherman, c. 1885. Pencil, sh. 5¹/₈ × 8¹/₄ in., sk. I, p. 14. KK inv. 1935.148 (no. 143).

72 Youthful satyr and Cupid, after ancient statuary, 1885-95. Pencil, sh. 8 × 4⁷/₈ in., sk. II, p. 43 v. KK inv. 1935.137 (no. 144).

73 Roman orator, after ancient statuary, 1885-95. Pencil, sh. 8¹/₄ × 4⁷/₈ in., sk. II, p. 45. KK inv. 1935.140 (no. 146).

74 After Puget: Hercules resting, 1886-90. Pencil, sh. 8³/₈ × 4³/₄ in., sk. II, p. 2 KK inv. 1935.153 (no. 149).

75 After Puget: Hercules resting, 1895-1900. Pencil, sh. 7³/₄ × 4⁷/₈ in., sk. III, p. 21. KK inv. 1935.142 (no. 151).

70

72 73

74 75

76
77
78
79
80
81
82
83
84
85

76 Anatomical model and interior with chair, 1885-95. Pencil, sh. 12¼ × 18¾ in. KK inv. 1934.203 (no. 153).

77 After Pollaiuolo: Charles VIII, c. 1885. Pencil, sh. 8⅛ × 5⅛ in., sk. I, p. 28. KK inv. 1935.129 (no. 155).

78 Peasant with arms crossed, 1890-92. Pencil, sh. 15 × 11⅜ in. KK inv. 1934.204 (no. 156).

79 Apollo, called Bonus Eventus, after ancient statuary, c. 1895. Pencil, sh. 8¼ × 5⅛ in., sk. I, p. 13. KK inv. 1935.144 (no. 157).

80 Borghese Mars, after ancient statuary, 1890-95. Pencil, sh. 8⅜ × 5⅛ in., sk. I, p. 27. v. KK inv. 1935.156 (no. 160).

81 Borghese Mars, after ancient statuary, 1890-95. Pencil, sh. 8 × 4¾ in., sk. II, p. 3. KK inv. 1935.133 (no. 162).

82 Borghese Mars, after ancient statuary, 1895-1900. Pencil, sh. 8⅛ × 4⅞ in., sk. I, p. 16. KK inv. 1935.135 (no. 163).

83 After Coustou: Adonis, 1895-1900. Pencil, sh. 8¼ × 5⅛ in., sk. I, p. 12. KK inv. 1935.138 (no. 164).

84 Provençal landscape, 1887-88. Pencil, sh. 5 × 8 in., sk. III, p. 16. KK inv. 1935.181 v. (no. 168).

85 Flower, c. 1890. Pencil, sh. 8 × 5 in., sk. III, p. 8. KK inv. 1935.171 v. (no. 170).

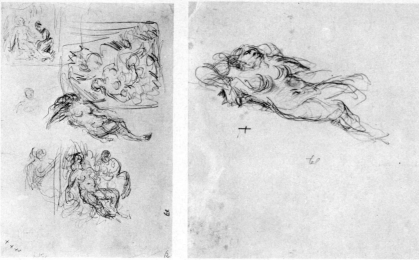

86

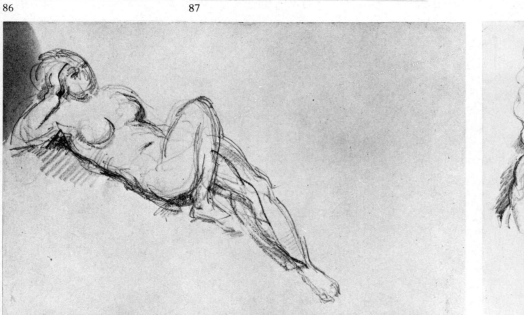

87

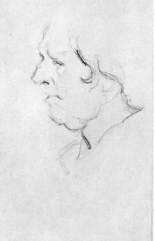

88 89

86 Studies for Bathsheba,
 1880-90. Pencil, sh.
 11³/₈ × 7¹/₂ in. KK inv.
 1934.199 (no. 176).
87 Reclining female nude,
 1880-90. Pencil, sh.
 8¹/₄ × 7³/₈ in. KK inv.
 1934.197 (no. 177).
88 Reclining female nude,
 1890-95. Pencil, sh.
 5 × 7⁷/₈ in., sk. III, p.
 7. KK inv. 1935.167
 (no. 178).
89 After Desjardins: The
 painter Pierre Mignard.
 Pencil, sh. 8 × 4⁷/₈ in.,
 sk. II, p. 43. KK inv.
 1935.137 (no. 182).
90 After Bernini: Cardinal
 Richelieu, 1895-1900.

Pencil, sh. 8¹/₄ × 4⁷/₈
in., sk. II, p. 5 KK inv.
1935.113 (no. 184).
91 After Coysevox: Le
 Grand Condé,
 1894-96. Pencil, sh.
 8¹/₄ × 4³/₄ in., sk. 11, p.
 8 KK inv. 1935.112
 (no. 185)
92 After Houdon:
 Voltaire, c. 1885.
 Pencil, sh. 8¹/₈ × 5¹/₈
 in., sk. I, p. 19. KK
 inv. 1935.125 (no.
 186).
93 After G. Coustou:
 Dareres de la Tour, c.
 1895. Pencil, sh. 8 × 5
 in., sk. I, p. 3. KK inv.
 1935.127 (no. 188).

90 91 92 93

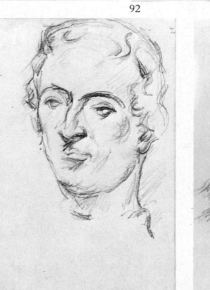

92

94 95 96

94 After G. Coustou:
 Dareres de la Tour, c.
 1895. Pencil and dab of
 green watercolor, sh.
 8¹/₄ × 5¹/₈ in., sk. I, p.
 7. KK inv. 1935.126
 (no. 189).
95 After Mino da Fiesole:
 Rinaldo della Luna,
 1890-1900. Pencil, sh.
 8 × 5 in., sk. I, p. 24.
 KK inv. 1935.128 (no.
 190).
96 After J. Chinard: Bust
 of a man, c. 1900.
 Pencil, sh. 8¹/₄ × 5¹/₈
 in., sk. I, p. 22. KK
 inv. 1935.118 (no.
 191).

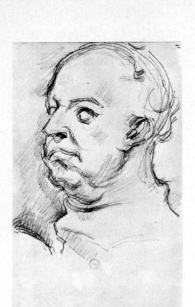

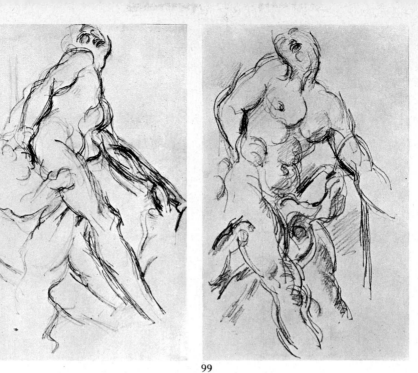

97

98

99

97　After a bust, 1890–1900.
　　Pencil, sh. 8¹/₄ × 5¹/₈ in., sk. I,
　　p. 15. KK inv. 1935.121 (no.
　　192).

98　After Puget: Milo of Croton,
　　c. 1883–88. Pencil, sh.
　　8¹/₄ × 4³/₄ in., sk. II, p. 1. KK
　　inv. 1935.151 (no. 195).

99　After Puget: Milo of Croton,
　　c. 1900. Pencil, sh. 8³/₈ × 5¹/₈
　　in., sk. I, p. 20. KK inv.
　　1935.150 (no. 197).

100　After Titian and Rubens: Eve
　　plucking the apple, c. 1895.
　　Pencil, sh. 8³/₈ × 5¹/₈ in., sk I,
　　p. 27. KK inv. 1935.156 (no
　　199).

101　After Coysevox: Marie Serre,
　　c. 1900. Pencil, sh. 8¹/₄ × 4³/₄
　　in., sk II, p. 49. KK inv.
　　1935.131 (no. 203).

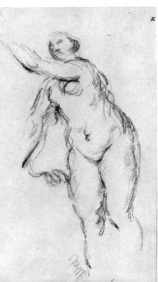

100

101

102

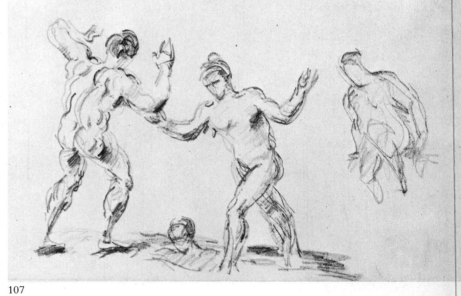

103

104

107

105

106

102　After a bust of Emperor
　　Caracalla, c. 1900. Pencil, sh.
　　8¹/₄ × 4³/₄ in., sk. II, p. 44.
　　KK inv. 1935.117 (no. 204).

103　After a bust of Emperor
　　Titus, c. 1900. Pencil, sh.
　　8¹/₄ × 5¹/₈ in., sk I, p. 18. KK
　　inv. 1935.116 (no. 205).

104　After Girardon: Nicolas
　　Boileau–Despréaux, c. 1900.
　　Pencil, sh. 8¹/₈ × 5 in., sk. I,
　　p. 29. KK inv. 1935.115 (no.
　　206).

105　After Desiderio da
　　Settignano: Bust of a boy, c.
　　1900. Pencil, sh. 7⁷/₈ × 4⁷/₈
　　in., sk. II, p. 4. v. KK inv.
　　1935.130 (no. 208).

106　Bather with arms raised
　　behind his head, c. 1900.
　　Pencil, sh. 8 × 5 in., sk. III.
　　KK inv. 1934.212 v. (no.
　　210).

107　Bathers, 1904–06. Pencil and
　　watercolor, sh. 4⁷/₈ × 7⁵/₈ in.,
　　sk. III, p. 12. KK inv.
　　1935.172 (no. 211).

Books about Cézanne

Catalogues:
Lionello Venturi, *Cézanne, son art, son oeuvre*, 2 vols., Paris, 1936; A. Gatto and G. Orienti, *L'opera completa di Cézanne*, Milan, 1970 (Eng. trans., *The Complete Paintings of Cézanne*, New York-London, 1972).

Reminiscences and biographies:
Paul Alexis, *Émile Zola, notes d'un ami*, Paris, 1882; Émile Bernard, *Souvenirs sur Paul Cézanne*, Paris, 1921; Charles Camoin, "Souvenirs sur Cézanne," in *L'Amour de l'Art*, Paris, January 1921; Gustave Coquiot, *Cézanne*, Paris, 1919; Joachim Gasquet, *Cézanne*, Paris, 1921; Hans Graber, *Paul Cézanne nach eigenen und fremden Zeugnissen*, Basel, 1942; Edmond Jaloux, *Les saisons littéraires*, Fribourg, 1942; Leo Larguier, *Le dimanche avec Paul Cézanne*, Paris, 1925; Gerstle Mack, *Paul Cézanne*, New York-London, 1935; K. E. Osthaus, "Dernière visite à Cézanne," in *Marianne*, Paris, Feb. 22, 1939 (German trans. in *Das Feuer*, 1920; Eng. trans. in John Rewald, *Paul Cézanne*, Paris, 1956); Henri Perruchot, *La vie de Cézanne*, New York, 1948; Camille Pissarro, *Letters to His Son Lucien*, ed. by John Rewald, New York, 1943 (*Lettres à son fils Lucien*, Paris, 1950); John Rewald, *Cézanne, sa vie, son oeuvre, son amitié pour Zola*, Paris, 1939; Rewald, *Paul Cézanne*, New York, 1948; Rewald, *The Ordeal of Paul Cézanne*, London, 1950; Rewald, *Paul Cézanne: Correspondance*, Paris, 1937 (Eng. trans., *Letters*, New York-London, 1941); Georges Rivière, *Paul Cézanne, le peintre solitaire*, Paris, 1933; Ambroise Vollard, *Paul Cézanne*, Paris, 1914 (Eng. trans., *Paul Cézanne, His Life and Art*, New York-London, 1924).

Technique and aesthetic:
Kurt Badt, *Die Kunst Cézannes*, Munich, 1956 (Eng. trans., *The Art of Cézanne*, Berkeley-Los Angeles, 1965); G. Berthold, *Cézanne und die Alten Meister: Die Bedeutung der Zeichnungen Cézannes nach Werken anderer Künstler*, Stuttgart, 1958; Roger Fry, *Cézanne: A Study of His Development*, London, 1927, 1952; J. C. Goulinat, "Technique picturale: L'évolution du métier de Cézanne," in *L'Art Vivant*, Paris, March 1925; Liliane Guerry, *Cézanne et l'expression de l'espace*, Paris, 1950, 1966; Erle Loran, *Cézanne's Composition: Analysis of His Form with Diagrams and Photographs of His Motifs*, Berkeley-Los Angeles, 1943.

Monographs:
P.M. Auzas, *Peintures de Paul Cézanne*, Paris, 1944; A.C. Barnes and V. de Mazia, *The Art of Cézanne*, New York, 1939; Jean Cassou, *Les baigneuses*, Paris, 1947; Raymond Cogniat, *Cézanne*, Paris, 1939; Bernard Dorival, *Cézanne*, Paris-New York, 1948; Frank Elgar, *Cézanne*, London-New York, 1969; Elie Faure, *Paul Cézanne*, Paris, 1910; P.H. Feist, *Paul Cézanne*, Leipzig, 1963; H.G. Fell, *Cézanne*, London, 1934; René Huyghe, *Cézanne*, Paris, 1936; N. Javorskaja, *Paul Cézanne*, Milan, 1935; E.A. Jewell, *Cézanne*, New York, 1944; André Lhote, *Cézanne*, Lausanne, 1949; Julius Meier-Graefe, *Cézanne*

und sein Kreis, Munich, 1922 (Eng. trans., *Cézanne*, London-New York, 1927); M. de Monts de Savasse, *Cézanne*, Paris, 1963; M. de Micheli, *Cézanne*, Florence, 1967; R.W. Murphy, *The World of Cézanne*, New York, 1968; A. Neumeyer, *Cézanne's Drawings*, New York, 1958; Fritz Novotny, *Cézanne*, Vienna-New York-London, 1937; Kurt Pfister, *Cézanne: Gestalt, Werk, Mythos*, Potsdam, 1927; Nello Ponente, *Cézanne*, Milan, 1966; Maurice Raynal, *Cézanne*, Geneva-London-New York, 1954; Theodore Reff, *Studies in the Drawings of Paul Cézanne*, Cambridge (Mass.), 1958; Rainer Maria Rilke, *Briefe über Cézanne*, Wiesbaden, 1952; D. Robbins, *Cézanne and Structure in Modern Painting*, New York, 1963; Meyer Schapiro, *Paul Cézanne*, New York-London, 1952; Georg Schmidt, *Aquarelles de Paul Cézanne*, Basel, 1952; H.L. Sherman, *Cézanne and Visual Form*, Columbus (Ohio), 1952; M. Waldvogel, *The Bathers of Paul Cézanne*, Cambridge (Mass.), 1961.

Articles:
Wayne V. Andersen, "Cézanne's Carnet moiré," *Burlington Magazine*, 1965; Kurt Badt, "Cézanne et la Montagne Sainte-Victoire," *L'Amour de l'Art*, 1938; Germain Bazin, "Cézanne devant l'Impressionisme," *Labyrinthe*, February 1945; J. Carpenter, "Cézanne and Tradition," *Art Bulletin*, 1951; Adrien Chappuis, "Cézanne dessinateur: copies et illustrations," *Gazette des Beaux-Arts*, 1965; Georges Charensol, "Aix et Cézanne," *L'Art Vivant*, 1925; Douglas Cooper, "Cézanne's Chronology," *Burlington Magazine*, 1956; F.B. Deknatel, "Manet and the Formation of Cézanne's Art," *College Art Journal*, March 1942; Maurice Denis, "L'aventure posthume de Cézanne," *Prométhée*, 1939; I. Eichmann, "Ein Beitrag zur Entwicklungsgeschichte der französischen Malerei im 19. Jahrh.," Prague, 1936; H. Fegers, "Hans von Marées und P. Cézanne," *Festschrift Hubert Schrade*, Stuttgart, 1960; Lawrence Gowing, "Notes on the Development of Cézanne," *Burlington Magazine*, 1956; Liliane Guerry, "Estétique du portrait cézannien," *Revue d'Esthétique*, 1961; G. H. Hamilton, "Cézanne, Bergson and the Image of Time," *College Art Journal*, 1956; S. Lichtenstein, "Cézanne and Delacroix," *Art Bulletin*, 1964; Maurice Merleau-Ponty, "Le doute de Cézanne," *Les temps Modernes*, 1946; Fritz Novotny, "Das Problem des Menschen Cézanne im Verhältnis zu seiner Kunst," *Zeitschrift für Aesthetik...*, XXVI, 2, 1932; Theodore Ref, "Cézanne and Poussin," *Journal of the Warburg Institute*, 1960; John Rewald, "Sources d'inspiration de Cézanne," *L'Amour de l'Art*, 1936; Daniel Catton Rich, "Two Paintings Revealing the Kinship of Poussin and Cézanne," *Art News*, 1930; Theodore Rousseau, Jr., "Cézanne as an Old Master," *Art News*, 1952; Charles Sterling, "Cézanne et les maîtres d'autrefois," *La Renaissance*, 1936; Charles de Tolnay, "Zu Cézannes geschichtlicher Stellung," *Deutsche Vierteljahrschrift für Literaturwissenschaft und Geistesgeschichte*, Heft 1, 1933; M. Waldvogel, "A Problem in Cézanne's 'Grandes Baigneuses'," *Burlington Magazine*, 1962.